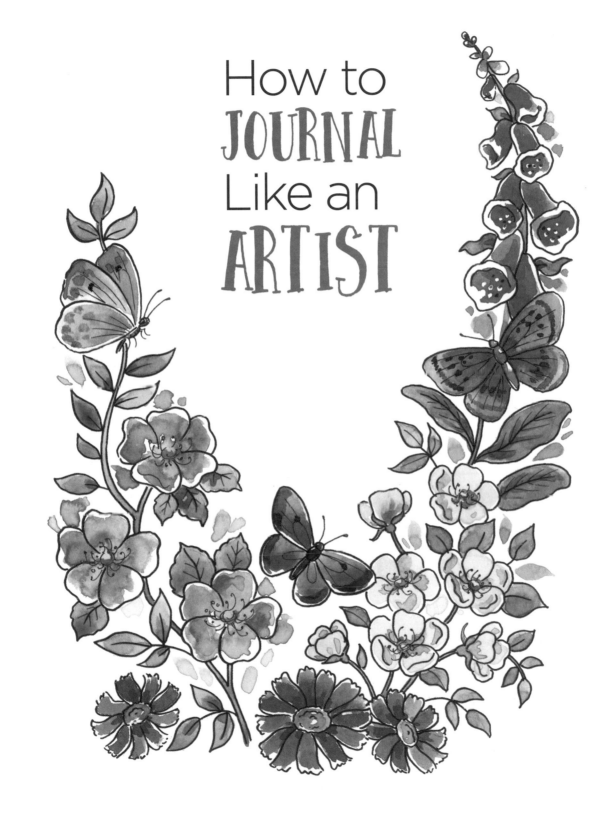

How to
JOURNAL
Like an
ARTIST

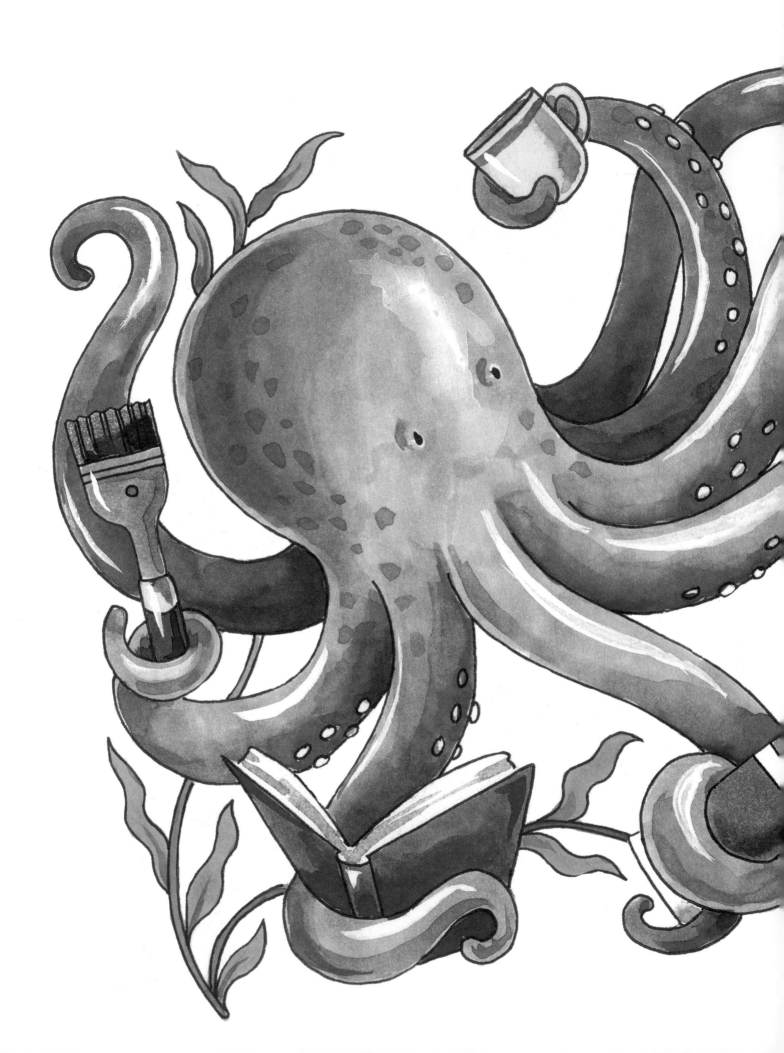

How to JOURNAL Like an ARTIST

A BEGINNER'S GUIDE TO KEEPING A SKETCH JOURNAL

Jane Maday

Get Creative 6

NEW YORK

Get Creative 6
An imprint of
Mixed Media Resources
19 W. 21st Street, Suite 601
New York, NY 10010
sixthandspringbooks.com

Editor
Lauren O'Neal

Creative Director
Irene Ledwith

Art Director
Francesca Pacchini

Chief Executive Officer
Caroline Kilmer

President
Art Joinnides

Chairman
Jay Stein

Manufactured in China

3 5 7 9 10 8 6 4 2

First Edition

CONTENTS

INTRODUCTION

Like a lot of people, I loved drawing and painting when I was a child. I was fortunate enough to have parents who encouraged me to make art into a career. Through the years, I have come to view my art not just as a way to make a living but also as something essential for my well-being. When the COVID-19 pandemic hit, I began to keep a journal to help with my mental health. It is now such an important part of my life that I decided to write this book in order to share what I have learned. Consider this a handbook for keeping an illustrated journal. I have included everything I can think of to help you on your own "journal journey," from advice on supplies, to step-by-step art lessons, to encouragement and inspiration. At the end of the book, you'll find illustrations you can cut out to use in your own journal, as well as practice pages so you can test out materials and practice what you've learned.

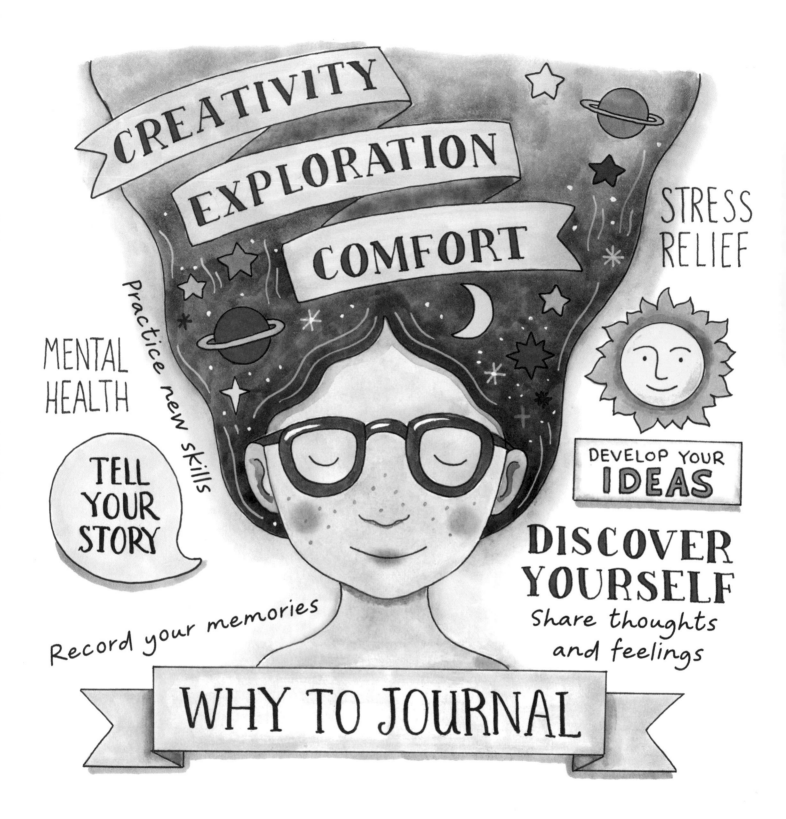

An art journal, also known as a sketch journal or illustrated journal, is similar to a traditional journal, but you use images instead of (or in addition to) words. It's the book of your life, the things you feel, an expression of the creativity within you. It is for YOU, a colorful conversation with yourself.

STARTING A JOURNAL

> Fill your paper with the breathings of your heart.
>
> WM. WORDSWORTH

Illustrating your life can become quite addictive. My day just isn't complete unless I make time for my journal, even if it's just a few minutes of sketching or jotting down notes.

Getting started might seem a little intimidating, so try scheduling time for it each day. As you get used to journaling, you'll see improvement in your skills, you'll become more creative, and you'll start thinking in a more positive and mindful way.

Chapter 1

TOOLS AND MATERIALS

What art supplies should you use in your art journal? Whatever you want! You can draw with pencils or pens, color with markers or colored pencils, paint with watercolors or acrylics, or even cut out images from magazines to create collages. This chapter will introduce you to some of the most common tools and materials. (And turn to page 126 for images you can cut out and use in collages!)

WELCOME TO THE HAPPY ZONE

My studio is definitely my happy place. There are few things better than being surrounded by your favorite art materials. These are the supplies that I use most frequently in my journal.

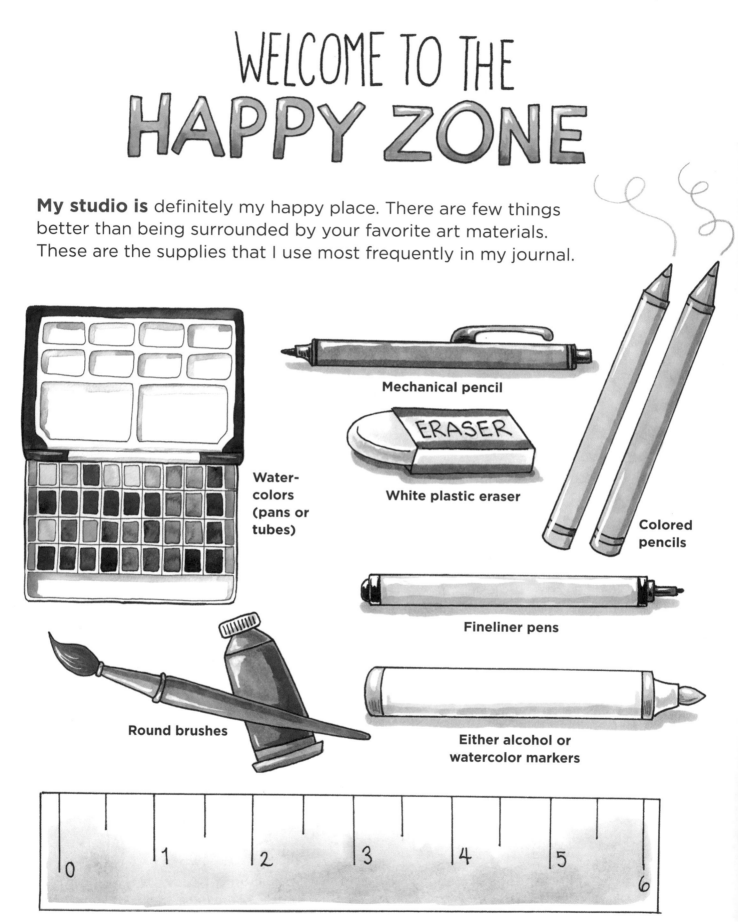

Water-colors (pans or tubes)

Mechanical pencil

White plastic eraser

Colored pencils

Fineliner pens

Round brushes

Either alcohol or watercolor markers

Clear plastic ruler

Favorite Journals

A MESSY DESK IS A SIGN OF A CREATIVE MIND

OOPS

INK

Picking a journal is a personal choice. Consider what size feels most comfortable and whether you need it to be portable. The medium you plan to use is also important. For wet media, I like paper with a thickness of at least 140 lb (300 gsm). For dry media, look for paper that is at least 65 lb (140 gsm).

There is a wide variety of tools available to you as you start your journal journey. How much you spend is up to you and your personal budget, but I do recommend buying high-quality supplies as much as you're able. Once you've chosen your journal or sketchbook, consider what media you will feel most comfortable with. All you really need are a pencil and eraser. For adding color, I recommend starting with markers or colored pencils, as you're likely familiar with them from childhood. As you gain confidence, watercolors are a good next step.

ADDITIONAL SUPPLIES
YOU MIGHT NEED

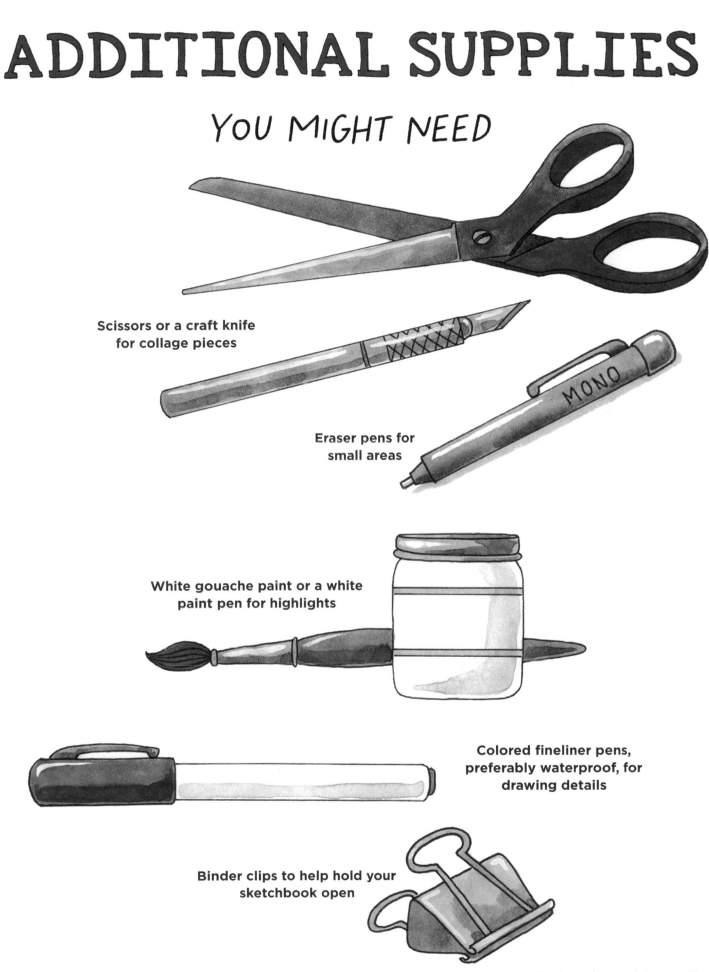

Scissors or a craft knife for collage pieces

Eraser pens for small areas

White gouache paint or a white paint pen for highlights

Colored fineliner pens, preferably waterproof, for drawing details

Binder clips to help hold your sketchbook open

WATERCOLOR

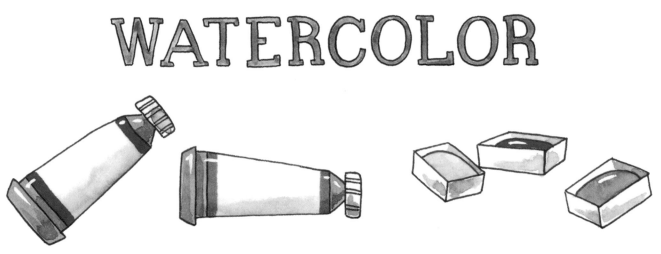

Watercolors come in tubes and pans. Pans are blocks of solid paint. Tubes contain paint in a more liquid form. Both require diluting with clean water.

Palettes are made from porcelain, plastic, or enamel, and come in many shapes and sizes. Tube paints require a palette.

I use round brushes almost exclusively. The tips are good for details, and they hold enough paint for washes. Natural bristles are better than synthetic.

Flat brushes are good for background washes and large shapes. You'll have more control if you choose short-handled brushes.

Simple Watercolor Techniques

When painting with watercolor, the intensity of the color depends on the amount of water you use for diluting the pigment. In this example, the left side is painted with watercolor mixed with quite a lot of water on the palette.

To blend one color into another, wet the paper first. Paint the pure colors on either end, then work quickly toward the middle. Try not to stroke your brush back and forth across the blended area, or you won't get a smooth blend.

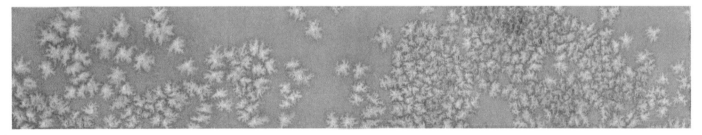

A fun way to add texture to a background is to sprinkle it with salt while the paint is still wet. Don't add any more paint afterward, or the texture will be ruined. Let it air-dry naturally.

Once you've painted a base color, you can add more transparent layers over the top. Each layer must be completely dry before you paint the next layer on top.

More Watercolor Techniques

Lift color out. On the left, I dabbed wet watercolor with a dry paper towel to create texture. On the right, I lifted color with a damp brush after the base color was dry.

Wet into wet. Wet the paper with clean water on the brush. Drop colors into the wet area and let them flow and blend.

Sponge textures. Dip a damp sea sponge into a puddle of paint. Pat the pigment onto a dry layer of paint.

Spatter. Load an old toothbrush with paint. For small spatters, run your thumb over the bristles. For larger spatters, tap the brush across your hand or wrist.

MARKERS

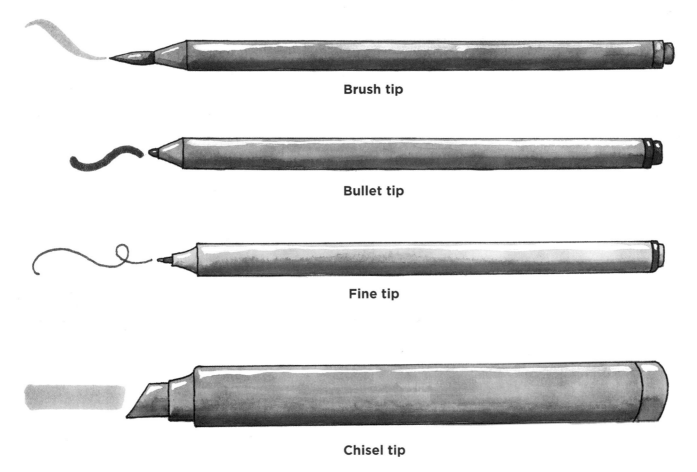

Brush tip

Bullet tip

Fine tip

Chisel tip

Watercolor vs. Alcohol Markers

1. Watercolor markers can be blended or diluted with water.

2. Multiple layers can damage paper.

3. Usually cheaper than alcohol markers.

4. Can be stored either vertically or horizontally.

1. Alcohol markers make seamless blends and flat areas.

2. Will bleed through most papers. Smooth, nonabsorbent paper is best. Can make many layers without paper damage.

3. Some can be refilled.

4. Should be stored horizontally.

ALCOHOL MARKERS

Alcohol markers will bleed through almost all papers, so be sure to keep a sheet of scrap paper underneath your drawing. Smooth marker paper is best, as textured papers will damage the marker tip, and absorbent papers will soak up too much ink.

BASE COLOR 1ST SHADING LAYER 2ND SHADING LAYER

With alcohol markers, start with the lightest color. Shade with a darker color from the same color family, then go over the edge with the light color. Repeat as needed. You can also add shading with watercolor or colored pencil. Make sure your ink outlines are dry and that all pencil marks are erased before you add color. Making a color chart is a good idea, so you'll know exactly how the colors will appear. (We'll discuss color in more depth on page 42.)

WATER-BASED MARKERS

Water-based markers are an easy way to get watercolor effects in your journal. For that reason, I prefer brush-tipped markers that feel like a paintbrush.

To blend with water-based markers, begin by coloring with the lightest color. Next, add shading with a darker color. Third, blend with clean water on a paintbrush. Before coloring your drawing, make sure that you've used a waterproof pen.

You can also blend different colors. Blending colors that are next to each other on the color wheel is an "analogous blend."

Be careful not to saturate the paper, or the surface will become rough.

WATERCOLOR PENCILS

1. My favorite method for using water-soluble pencils is to begin by coloring loosely, as if they were ordinary pencils. You can leave an area of plain white paper as a highlight if you wish.

2. Next, go over it with a damp brush. Clean your brush between colors. Your brush does not need to be sopping wet. Too wet and you might lift the color rather than blending it, and your paper might buckle.

3. Once your paper is completely dry, you can add more
layers and shading. Be patient: coloring on damp paper
will ruin the surface of the page. Add highlights with white
paint if desired.

COLORED PENCILS

We're all familiar with colored pencils from our school days. They're a simple and easily portable coloring tool. They are somewhat fragile, and sometimes the colored core inside can break. If this happens, you can try to mend the core by placing the pencil on a heating pad or baking in an oven for a few minutes at a low temperature.

Light pressure *Heavy pressure*

You can vary the tone by changing the amount of pressure you put on the pencil. Pressing harder equals darker colors.

Try blending colors by layering them. Layering colors gives more depth to your drawing.

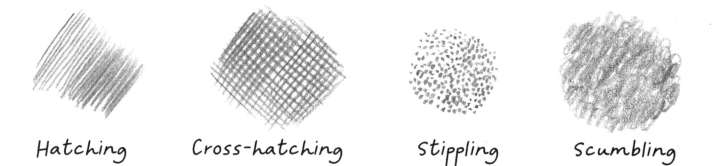

Hatching Cross-hatching Stippling Scumbling

There are different strokes you can use to add color and texture to your drawings.

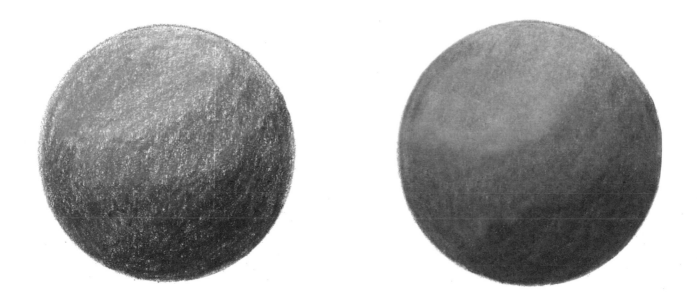

Colored pencils are usually either wax-based or oil-based. Wax-based pencils are slightly harder than oil-based pencils, and can be more difficult to blend. You can still achieve rich colors through layering, though, and they are the most common type of pencil. Harder pencils are better for details. Wax-based pencils are easier to blend, softer, and easier to erase.

You can also use solvents like mineral spirits to blend and smooth your colored pencil drawings. Many people use petroleum jelly for blending, but I advise against it. Over time, petroleum jelly will cause your paper to degrade.

The circle on the left shows colored pencil that has been layered. On the right, the circle has been blended with mineral spirits on a blending stump (a pencil-shaped stump made of compressed paper).

It's okay to mix media in order to get the effects you desire. Many people prefer to use markers or watercolor for their base coat of color, and then add shading and details with colored pencil.

1. Color the orange with alcohol markers or other preferred medium.

2. Shade with layers of colored pencil.

3. Add more details with colored pencil, then use white paint for highlights. White colored pencils are not good for highlighting because they're not opaque enough.

FINELINER PENS

Fineliner pens are popular drawing tools, and they come in a variety of line widths from 0.05 to 1.0 millimeters. The smaller numbers indicate a more delicate line, which is good for details. The larger numbers are wider lines, which are good for outlining or creating large drawings. Brush tips can give a more expressive line, and you can vary the width of the line by changing the pressure as you draw. Fineliner pens work best on smooth paper. I usually use pens with black, waterproof ink.

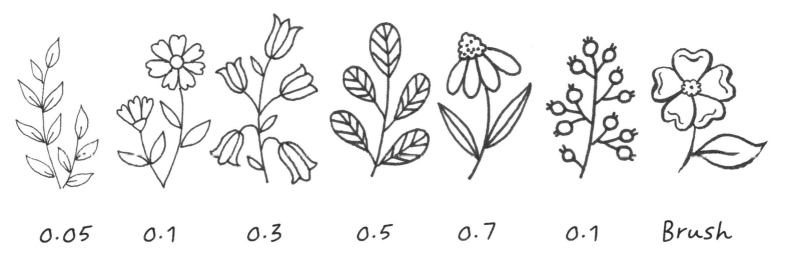

| 0.05 | 0.1 | 0.3 | 0.5 | 0.7 | 0.1 | Brush |

These sketches give examples of line widths, but keep in mind that width and labeling can vary between pen brands.

Using a variety of pens with different line widths can add interest and an artistic flair to your drawings.

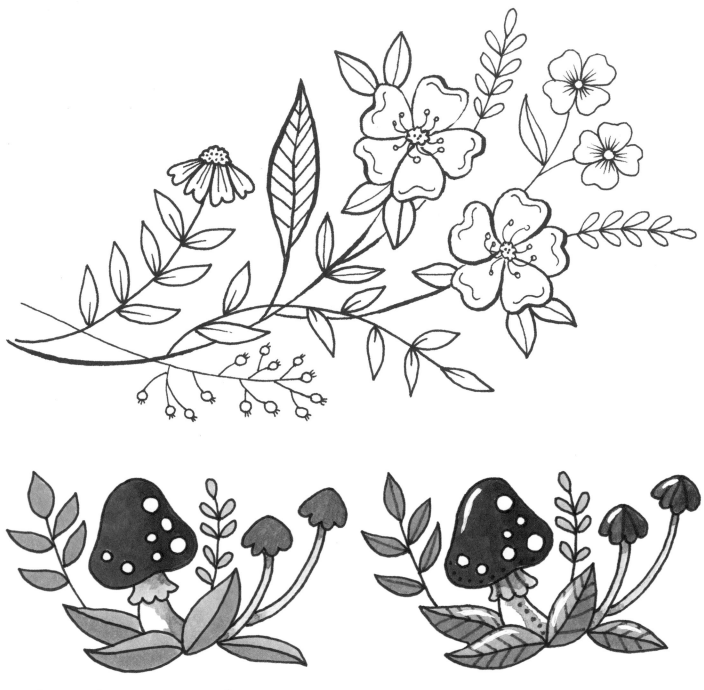

Without colored fineliners With colored fineliners

Fineliner pens also come in multiple colors, not just black. I like to use colored pens to add details on top of colored areas.

I usually prefer waterproof pens, but for sketching when you're out and about and don't want to carry too many supplies, sometimes a water-soluble pen and a paintbrush can give you a nice result.

1. Begin with a simple drawing of your subject.

2. Add light hatch marks for shading. You don't need to shade heavily.

3. Go over the shaded areas with the damp brush. Be careful not to smudge the outline too much.

Chapter 2

GETTING IN TOUCH WITH YOUR CREATIVE SIDE

Sometimes there's nothing more intimidating than a blank page. It doesn't matter if you're a beginner to art journaling or an old hand—it can be hard to find inspiration and silence your inner critic. This chapter will give you pointers on how to unleash your creativity and get your artistic juices flowing, so you can fully enjoy illustrating your daily life.

Like any skill, your drawing will improve with practice. I think of my sketch journal as both a mental exercise and a form of meditation. It is both a way of exploring my world and a record of my life and thoughts.

Another benefit to committing to a journal habit is that you'll see your own style develop and your art skills improve. You are under no obligation to share your sketches with anyone, although you may find that doing so will have a positive impact on your future efforts.

Make Time For Your Journal

Some people find it inhibiting to start a new, pristine sketchbook or journal. I actually have two on the go all the time. I have one high-quality sketchbook that I use for "finished" pages that I want to keep and share, and another well-used, scruffy book that I use for learning and experimentation. Nobody sees that book but me!

FINDING YOUR ART STYLE

Finding your artistic comfort zone takes time and practice. Seek out artists who inspire you, then analyze just what factors are appealing to you. Is it their color palette? Their drawing technique? Is it the subject matter that attracts you? Identify elements from other artists that you think are successful, then apply them to your own work, in your own way.

You don't need to buy lots of supplies to begin. I recommend buying things individually, rather than in large sets, so you can see what you like before spending too much.

FINDING YOUR DIRECTION

It can be tempting to try to copy our artistic heroes very closely, but it's hard to speak in someone else's voice. Your own voice and style will gradually evolve with time, but you can help the process by asking yourself some questions.

1. What excites you about art and journaling?

2. What are your favorite art supplies?

3. How do you like to work? Big and expressive or small and accurate?

The most important question is probably your end goals. Do you want to sketch and journal as a meditative self-care exercise? Is your main goal to improve your artistic skill? Are you looking at monetizing your efforts?

BOOST YOUR CREATIVITY

Sometimes you might find that you get stuck in a creative rut. Don't worry—it happens to everyone. Here are a few tips to help you stay motivated. Joining a group of like-minded individuals, either online or in person, is another way to get inspired!

1. Play and explore.
2. Focus on the process, not the result.
3. Try new art supplies and techniques.
4. Get out of your comfort zone.
5. Get inspired by your environment.

EXPERIMENT

Explore different media.

Pencil

Pen and ink

Watercolor

I know that when I look at my journal, I want to keep each page perfect, so I'm sometimes reluctant to really play or try new things. Try to get out of that mindset, and you'll open yourself up to growth. The best part of having a journal is that you get to play.

SILENCE THE INNER CRITIC

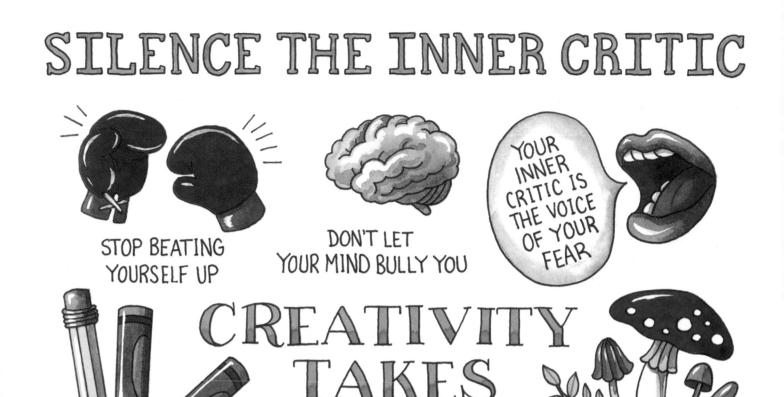

STOP BEATING YOURSELF UP

DON'T LET YOUR MIND BULLY YOU

YOUR INNER CRITIC IS THE VOICE OF YOUR FEAR

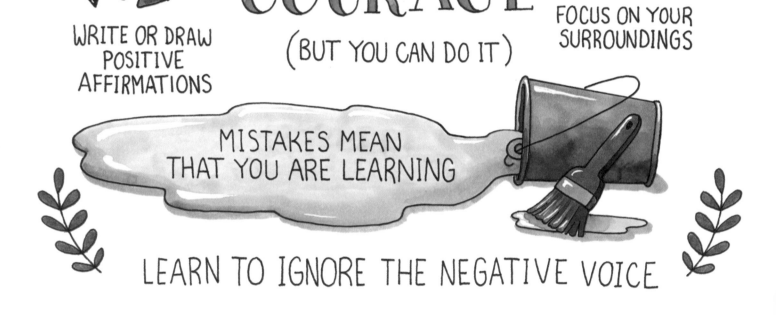

WRITE OR DRAW POSITIVE AFFIRMATIONS

CREATIVITY TAKES COURAGE (BUT YOU CAN DO IT)

FOCUS ON YOUR SURROUNDINGS

MISTAKES MEAN THAT YOU ARE LEARNING

LEARN TO IGNORE THE NEGATIVE VOICE

The inner critic is that little voice we all have inside us, telling us we're not good enough or talented enough. We can get in the habit of listening to these insecurities and fears, and that voice can seem very real. Recognizing that these thoughts are just a negative habit can help overcome them.

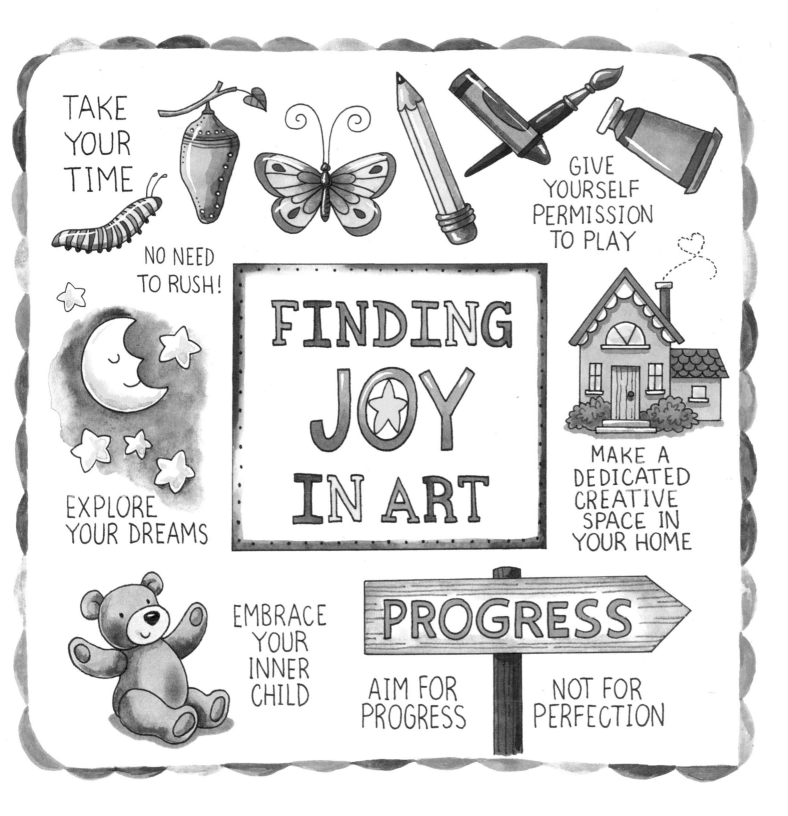

Art should be a source of comfort and joy, in my opinion. Remember that your art is just for you, and try to put aside the thoughts of how others might react to it.

Chapter 3

COLOR, SHADING, AND COMPOSITION

How do you mix colors? What's the difference between hatching and cross-hatching? Consider this chapter a quickstart guide or refresher course on basic art techniques that will help take your sketch journal to the next level. But remember, rules were meant to be broken! If there are days you feel like throwing caution to the wind and making up your own rules, it's your journal, and you can do whatever you want with it!

THE COLOR WHEEL

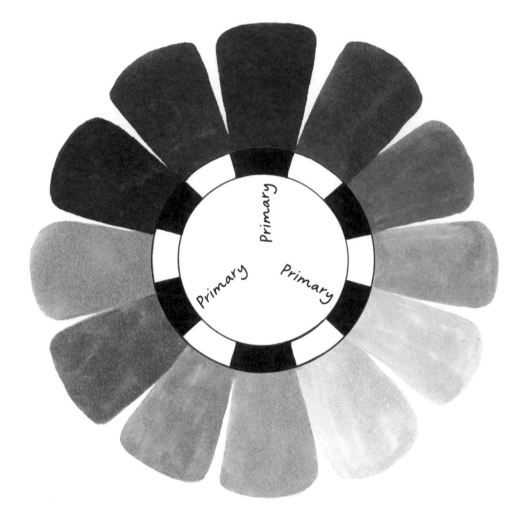

Color (also called "hue") is created based on the way an object reflects light. The color wheel shows how colors relate to each other and helps you create harmonious palettes. Primary colors cannot be made by mixing other colors. The primaries are red, yellow, and blue. Secondary colors are a mix of two primary colors. Tertiary colors are a mix of one primary and one secondary color. Shades are made by mixing a color with black, and tints are created by adding white to a color.

Analogous colors
(next to each other on the color wheel)

Complementary colors
(opposite each other on the color wheel)

MIXING COLORS

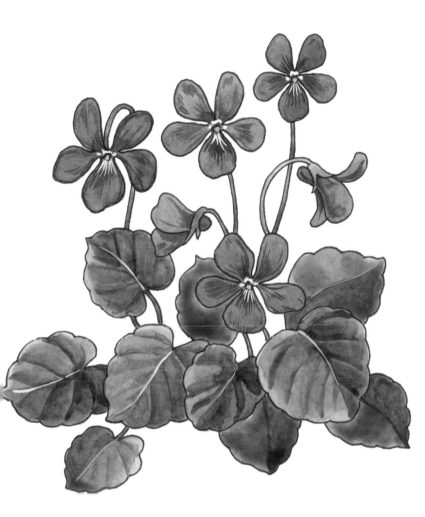

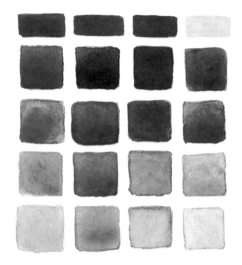

Ultramarine blue mixes

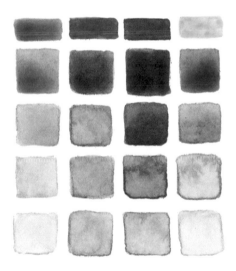

Cerulean blue mixes

Color temperature matters when mixing colors. There is a warm and cool version of each primary color. "Warm" blues are closer to red on the color wheel; "cool" blues are closer to yellow. "Warm" reds are closer to yellow, "cool" reds closer to blue. "Warm" yellows are closer to red, "cool" yellows closer to blue. The top color palette shows ultramarine blue (warm) mixed with cadmium red (warm), alizarin crimson (cool), and cadmium yellow (warm) watercolors. The bottom palette uses cerulean blue, which is cool. Notice how the greens look "cleaner" when you mix with a cool blue! The purples look less muddy when created with a cool red.

ALL ABOUT SHADING

Shading gives your drawings volume and dimension. Shading and highlights create interesting artwork. Contrast between highlights and shadows will help your artwork "pop" off the page.

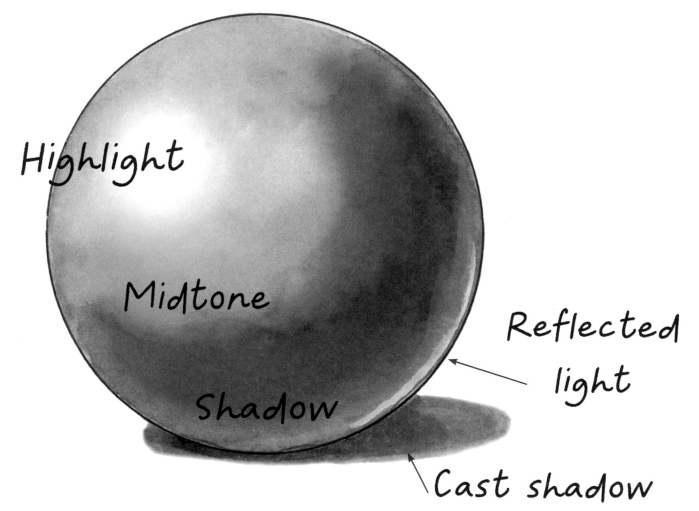

Highlight

Midtone

Reflected light

Shadow

Cast shadow

The *highlight* is where the light strikes an object, and is the lightest point. *Midtones* are the base colors, where there is no highlight or shadow. *Shadows* are on the opposite side of the highlight, where the light does not reach. The *cast shadow* is caused by the object blocking the light from reaching the area beyond. Sometimes the surface will cast *reflected light* onto the object.

SHADING WITH A PEN

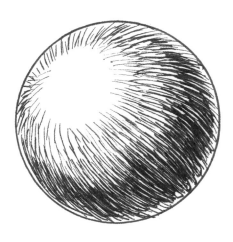

Hatching

Cross-hatching

Stippling

Scumbling

Shading and **highlighting** refer to how light affects an object. Value is the range of tones from light to dark. Values help convey the form of objects in your drawings. Shown here are some methods for shading using a pen or pencil. The highlights are left as plain paper. Leave an area of plain, uncolored paper as the highlight.

SHADING WITH COLOR

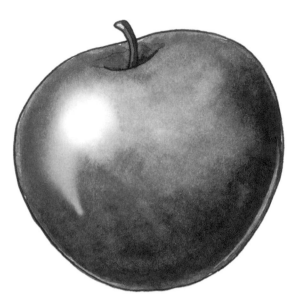

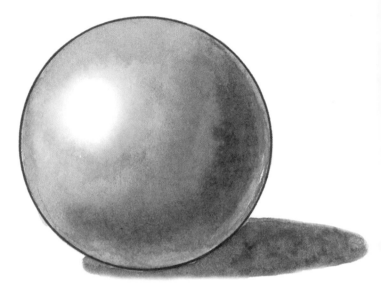

Your shading will have more depth if you add a bit of a color with a contrasting temperature. For example, I have added a cool color, blue, to the red of the apple in order to create tones for shading. Shading in this way gives the base color more vibrancy. Be careful with your color mixes, because combining two complementary colors will give you a muddy result. When shading skin tones, try adding soft blues and purples. Skin, from pale pink to the darkest rich browns, is always warm in tone. Cast shadows should have a small amount of the object's color as a reflection.

ADDING HIGHLIGHTS

Light comes from this side

1. Draw your object and fill in the base colors with watercolor or markers.

2. Decide which direction the light source is coming from. Use watercolor or colored pencils to create shadows on the opposite side from the light source.

3. Use white gouache to paint a highlight on the same side as the light source.

COLORING SNOW

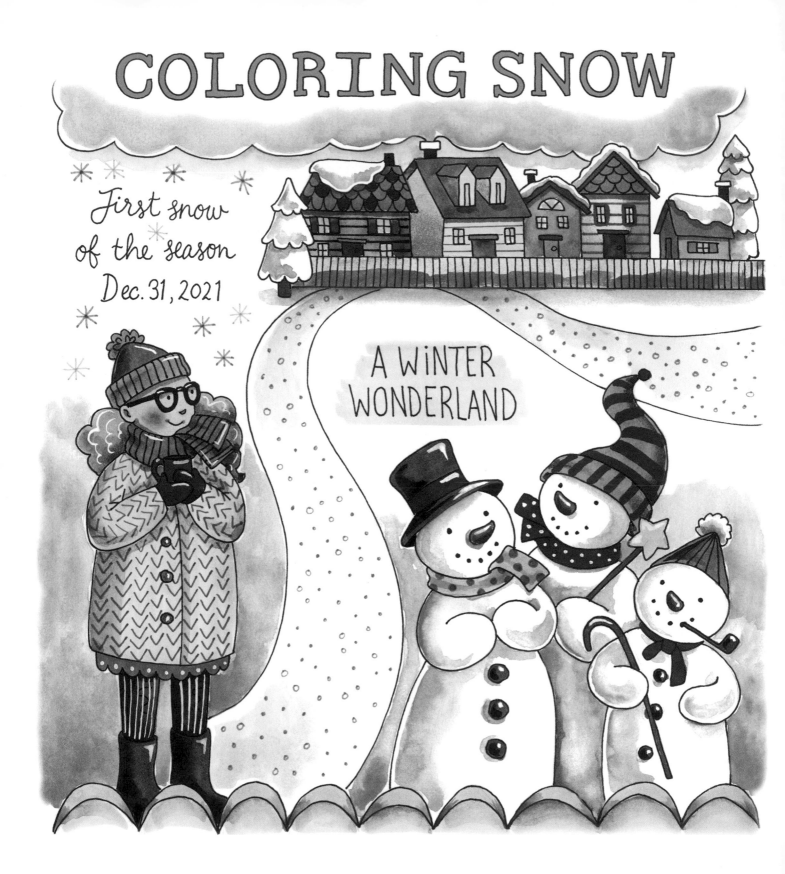

First snow
of the season
Dec. 31, 2021

A WINTER
WONDERLAND

Frequently, when people want to color snow, they think they need to color the white parts of the page. Actually, the key is in the shading. Snow reflects the colors of the sky, so I use blues and pinks.

It helps a white area stand out if you paint a background around it.

Snow reflects the sky, so I begin by shading with blue.

Adding a bit of pink or purple, as if it is dawn, makes the art more lively.

Finally, finish the details and other colors.

THUMBNAILS

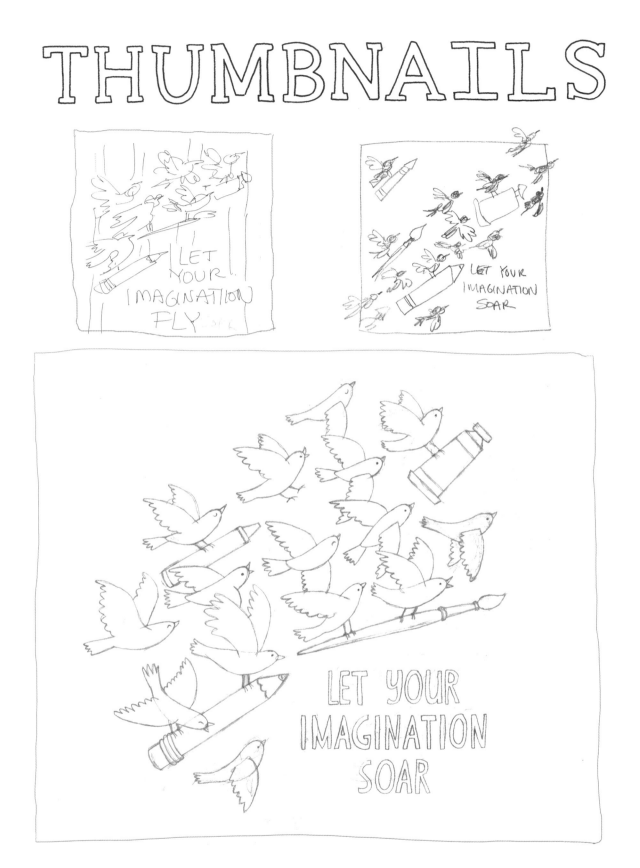

Thumbnails are very small, loose sketches that are helpful for planning your layout before you proceed to sketching your drawing. I keep a notebook of thumbnails of ideas for future pages.

COLOR ROUGHS

Color rough

Finished page

A color rough is a small, loose sketch that helps you work out your color scheme for a design. It's a good idea to get your colors worked out before you dive into the finished piece.

IDEA SKETCHES

cupcakes

sunshine

bumble bees

wildflowers

birdsong

SMALL DELIGHTS

pets

rainbows

puppy dogs

starry nights

fresh berries

sleeping kitties

I have a separate sketchbook with grid paper that I use to keep rough sketches of ideas for future journal pages. I used to think that I would remember my ideas in my head, but that didn't work!

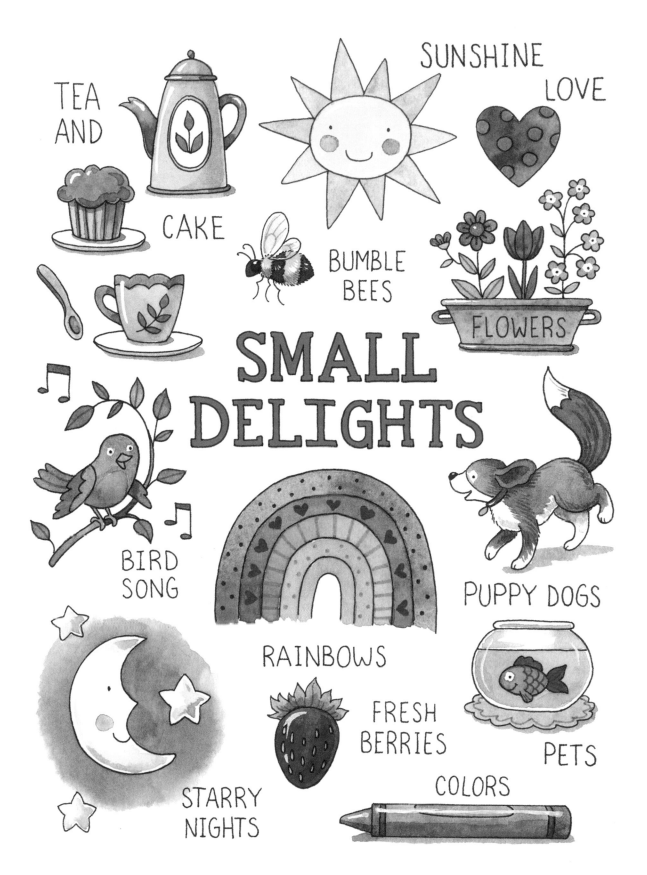

The finished page actually sticks pretty close to the very rough idea sketch. I left out the cat, and in hindsight I wish I had left him in, but remember, we don't dwell on our mistakes!

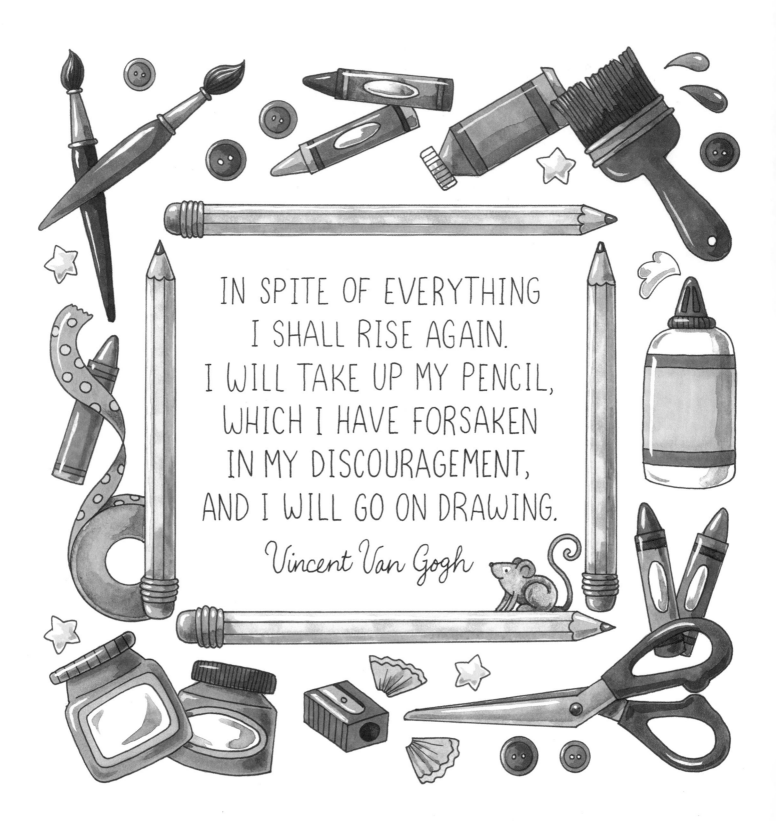

IN SPITE OF EVERYTHING
I SHALL RISE AGAIN.
I WILL TAKE UP MY PENCIL,
WHICH I HAVE FORSAKEN
IN MY DISCOURAGEMENT,
AND I WILL GO ON DRAWING.

Vincent Van Gogh

Little things can mean a lot. The tiny mouse in the corner of the text area adds more charm than its size would suggest. Adding colorful touches like the buttons and stars also serves to brighten the page and give it more interest.

TYING ELEMENTS TOGETHER

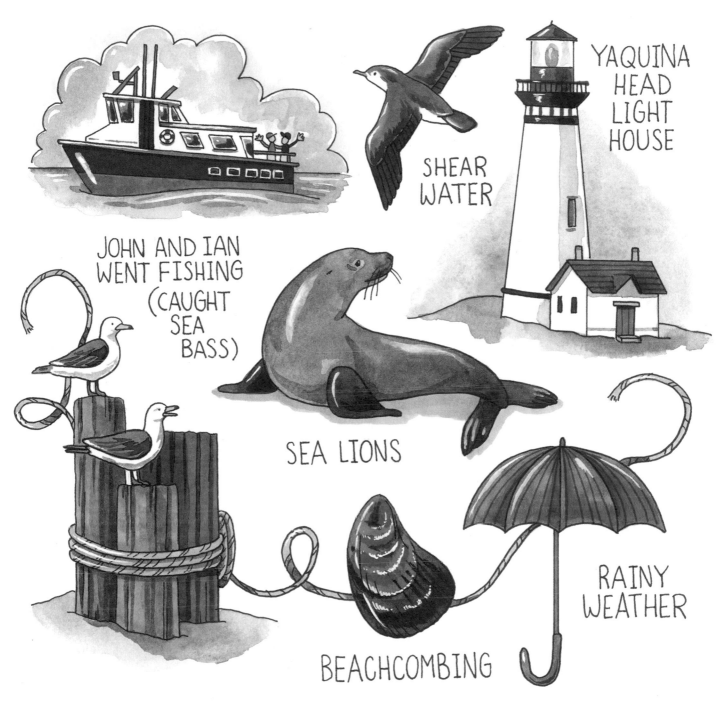

SHEAR WATER

YAQUINA HEAD LIGHT HOUSE

JOHN AND IAN WENT FISHING (CAUGHT SEA BASS)

SEA LIONS

BEACHCOMBING

RAINY WEATHER

When creating a composition, you want to guide the viewer's eye around the page. On this page, the angle of the shearwater's body leads your eye in a clockwise circle around the whole design, with the rope at the bottom of the page tying the elements together.

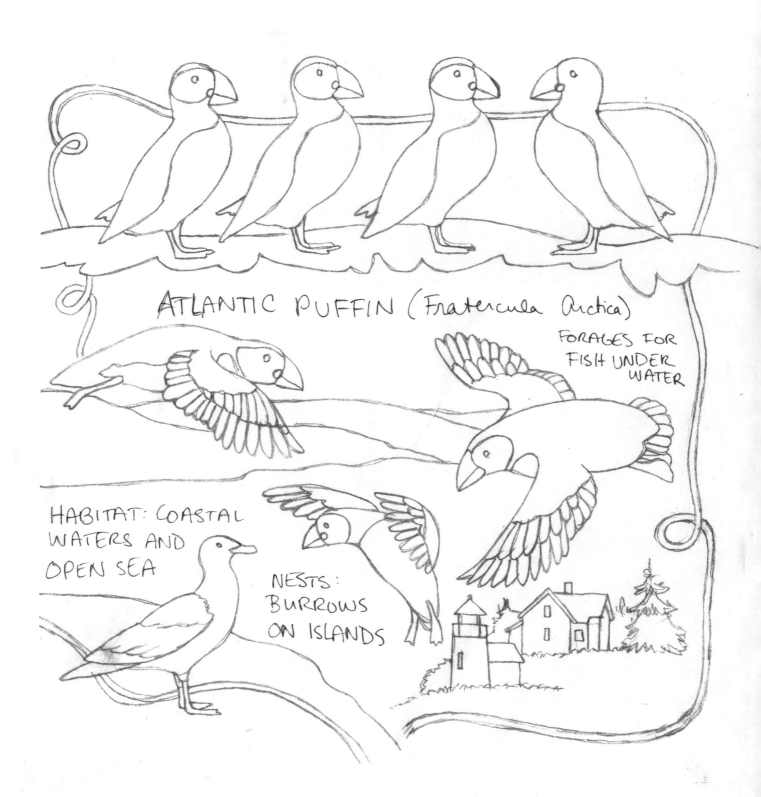

ATLANTIC PUFFIN (Fratercula Arctica)

FORAGES FOR FISH UNDER WATER

HABITAT: COASTAL WATERS AND OPEN SEA

NESTS: BURROWS ON ISLANDS

I like creating educational, factual journal pages about subjects that interest me. Puffins are my favorite bird, so I did some research and discovered some facts I wanted to include with my drawings. When creating such a page, it's important to consider the placement of the text and leave enough space for it.

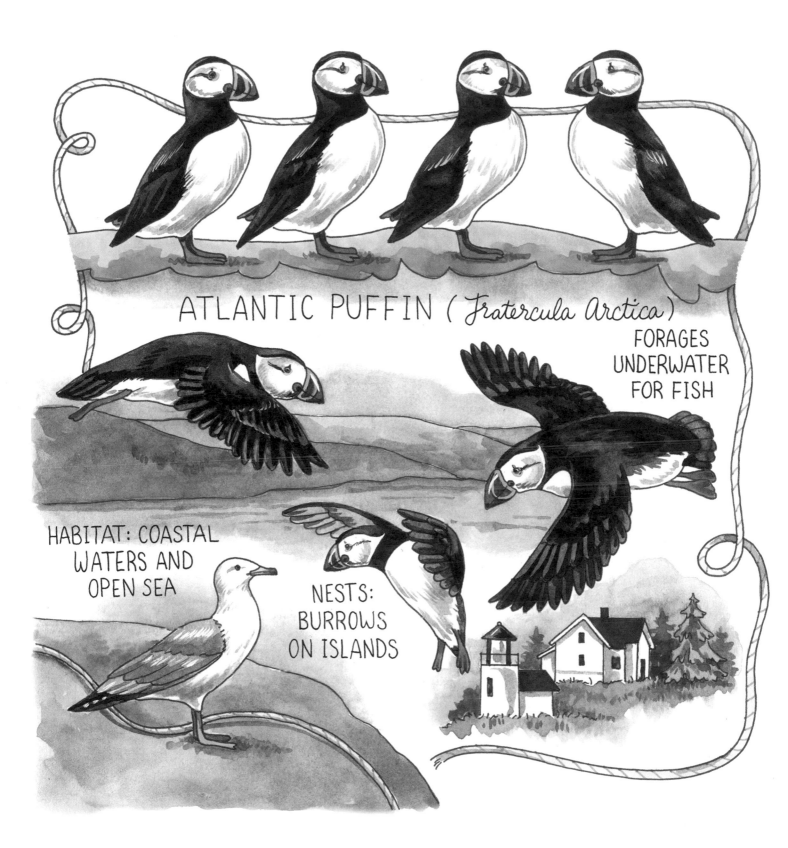

ATLANTIC PUFFIN (*Fratercula Arctica*)

FORAGES UNDERWATER FOR FISH

HABITAT: COASTAL WATERS AND OPEN SEA

NESTS: BURROWS ON ISLANDS

You can have as much or as little text as you'd like. On this page, I mostly wanted to explore how the birds looked in flight, and I added the information about puffins I'd researched.

Chapter 4

DRAWING YOUR DAILY LIFE

There are certain elements of daily life that you'll probably end up drawing frequently. These will vary from person to person: maybe your job involves a lot of driving and you'll draw your car a lot, or maybe you'll draw all the accoutrements of a hobby like knitting or baking. This chapter will give you instructions and tips on drawing some of the most common things we encounter day to day, like plants, pets, and people.

DRAW A FACE

Front view

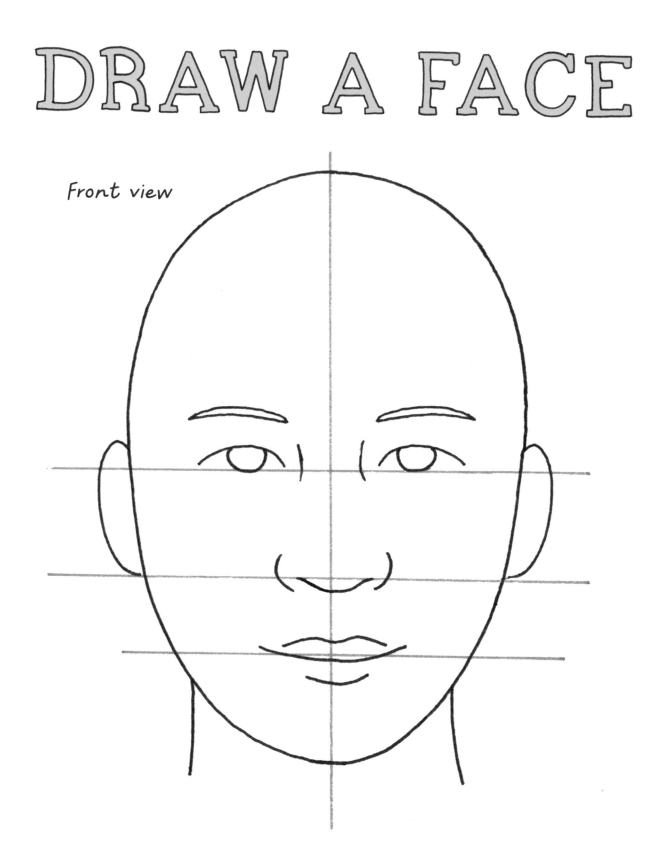

To draw a face, begin by drawing an oval shape. Some faces are slightly rounder or more square, but an oval is a good place to start. Divide the oval into quarters. Next, divide the lower portion into thirds. The eyes are on the line halfway down the head. The nose and mouth are on the bottom two-thirds.

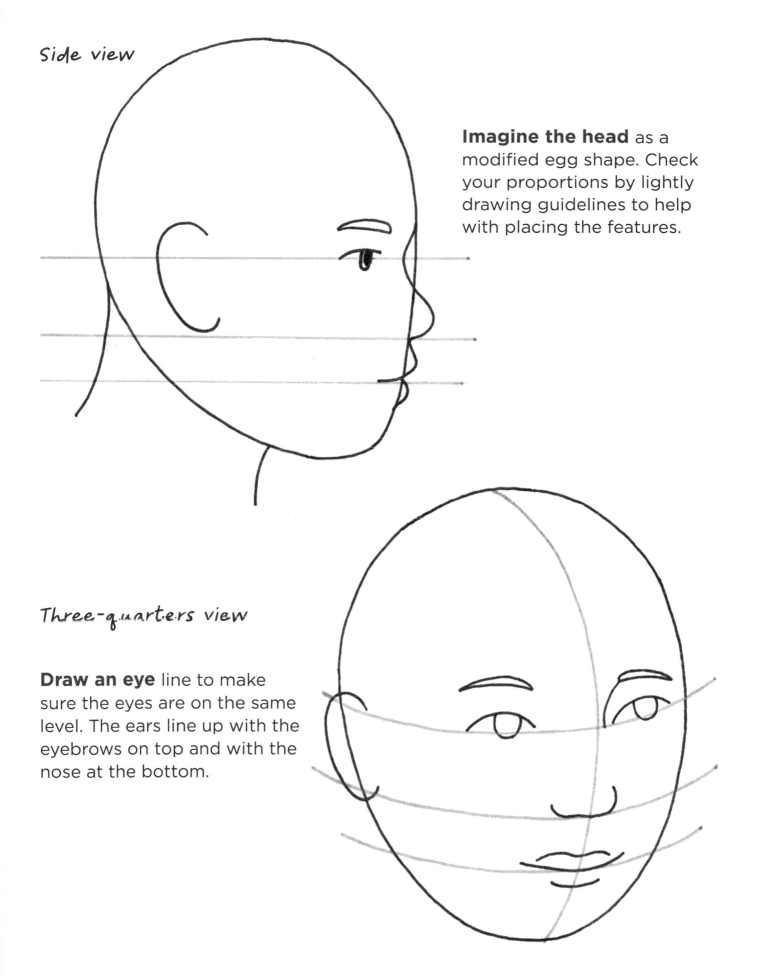

Side view

Imagine the head as a modified egg shape. Check your proportions by lightly drawing guidelines to help with placing the features.

Three-quarters view

Draw an eye line to make sure the eyes are on the same level. The ears line up with the eyebrows on top and with the nose at the bottom.

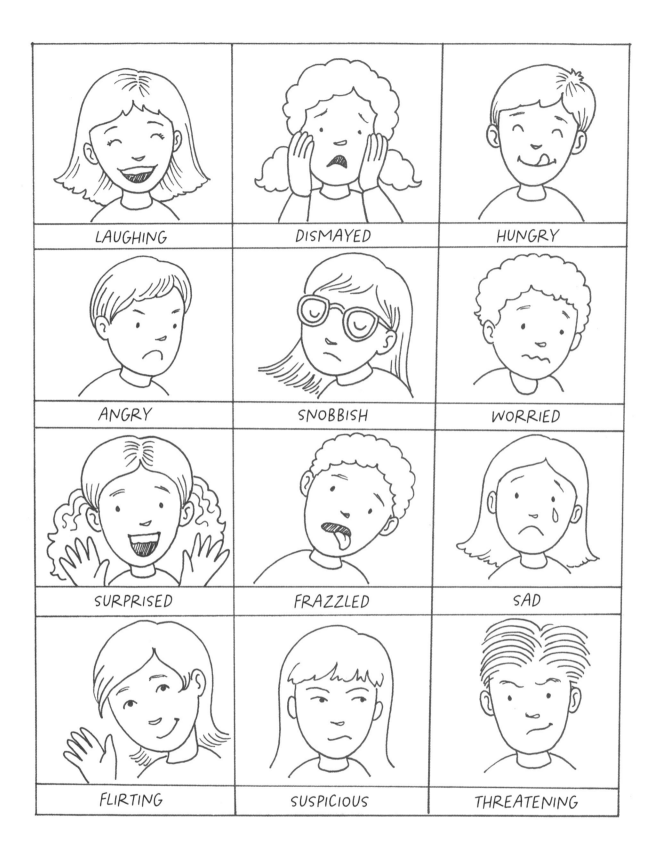

You can indicate expression with fairly simple changes to the features. Eyebrows help show emotion, and hand positions add to the expression. Notice the difference in direction between a happy eye that turns up and a sad eye that turns down.

ADULT PROPORTIONS

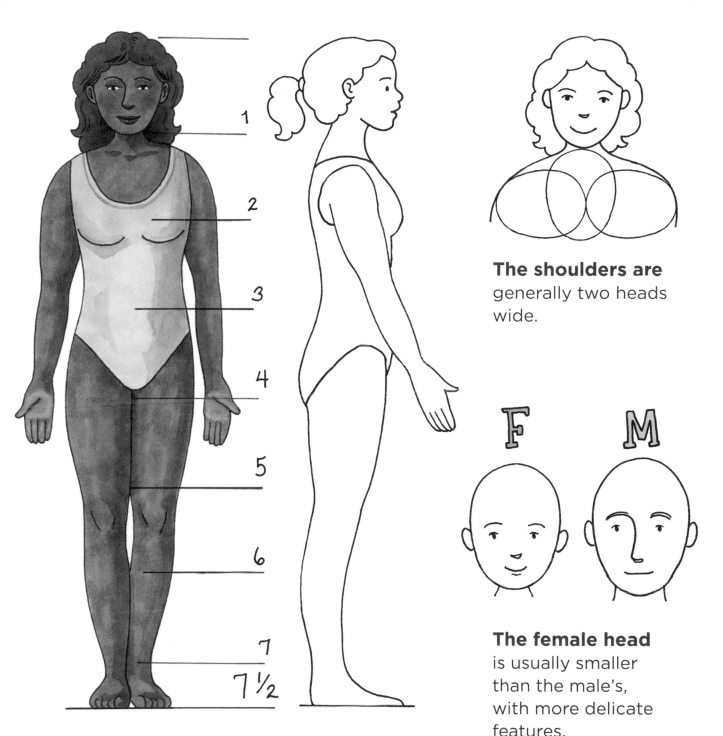

1
2
3
4
5
6
7
7½

The shoulders are generally two heads wide.

F M

The female head is usually smaller than the male's, with more delicate features.

Use the size of the head to determine body proportions. The average adult is 7.5–8 heads tall.

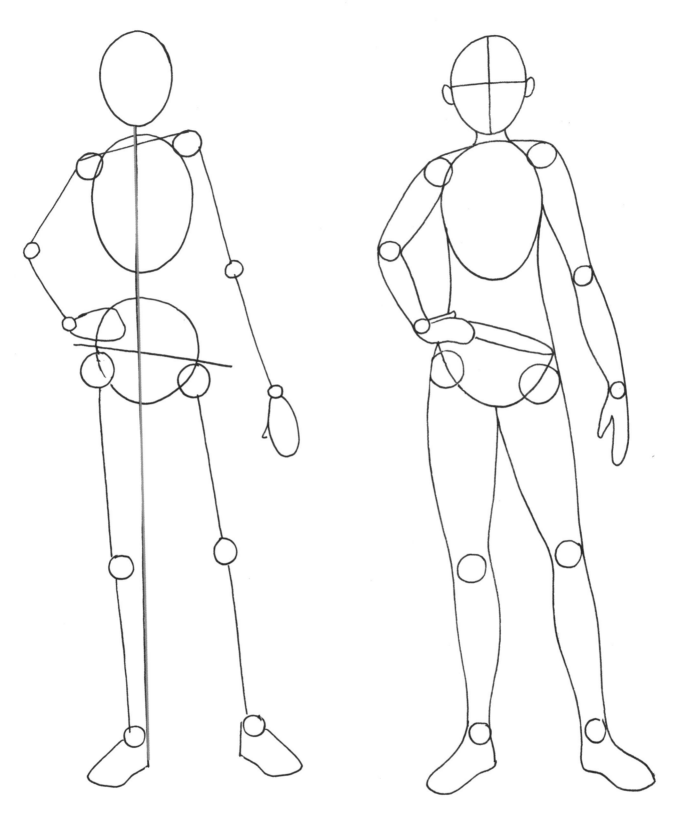

When drawing the figure, begin with the "line of balance." This is a perpendicular line that you'll construct the figure around. The head is always centered over the balance line. This is necessary to ground the body and give it weight. Then use egg shapes and lines to indicate the skeleton. Having a tilt to the shoulders and hips makes for a less static pose.

DRAWING LITTLE ONES

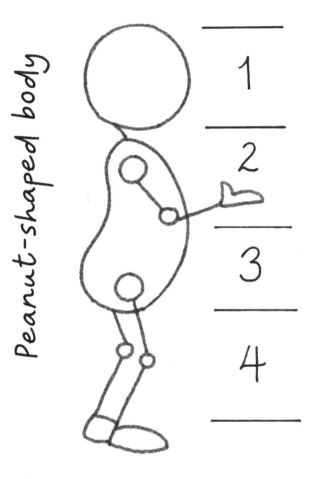

Peanut-shaped body

1
2
3
4

Children have heads that are larger in proportion to their bodies. They are four to five heads tall.

Babies are three to four heads tall. The neck doesn't show.

Children have bigger foreheads, so the eyes are below the center-line. The eyes are larger and spaced farther apart than on an adult face.

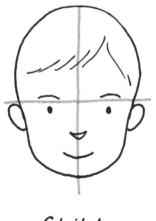

Baby Child

CHILDREN'S PROPORTIONS

Centerline

Eye

Nose

Mouth

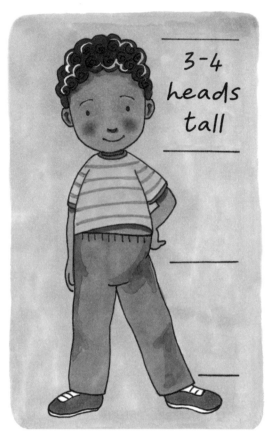

3-4 heads tall

12-13 years

8-10 years

Toddler

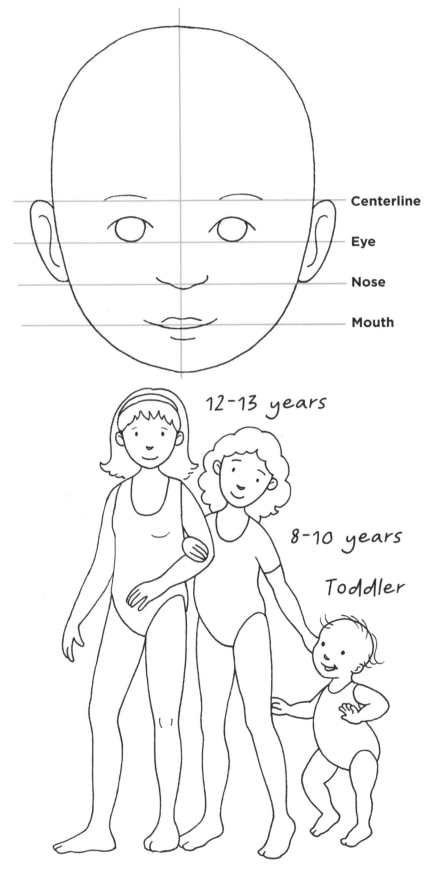

Exaggerate the head size for extra cuteness. The ratio of head size to body size changes as children grow.

ALL ABOUT HANDS

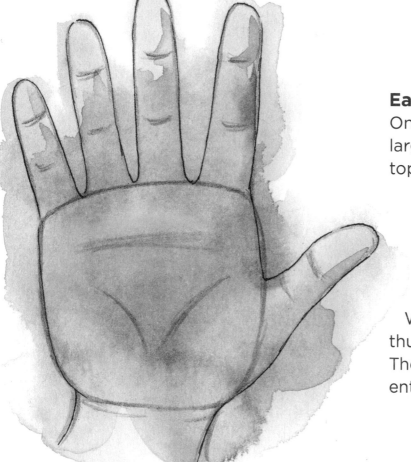

Each finger has three sections. On the thumb, the top segment is largest, while on the fingers, the top segment is smallest.

When the palms are up, the thumb points toward the body. The palm is half the length of the entire hand. Draw the palm first.

Toddler hands are small in comparison to head size, and are pudgier than adult hands. When drawing hands, sketch the basic mitten shape lightly in pencil first. Be wary of adding every line and wrinkle when adding color. It's easy for hands to look dirty if you add too much shading.

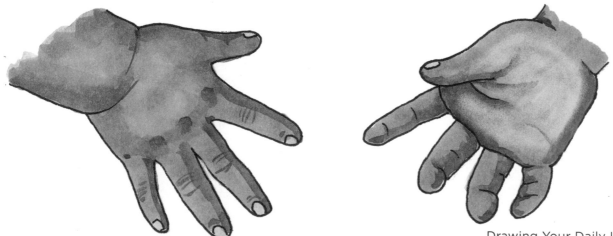

Drawing Hands

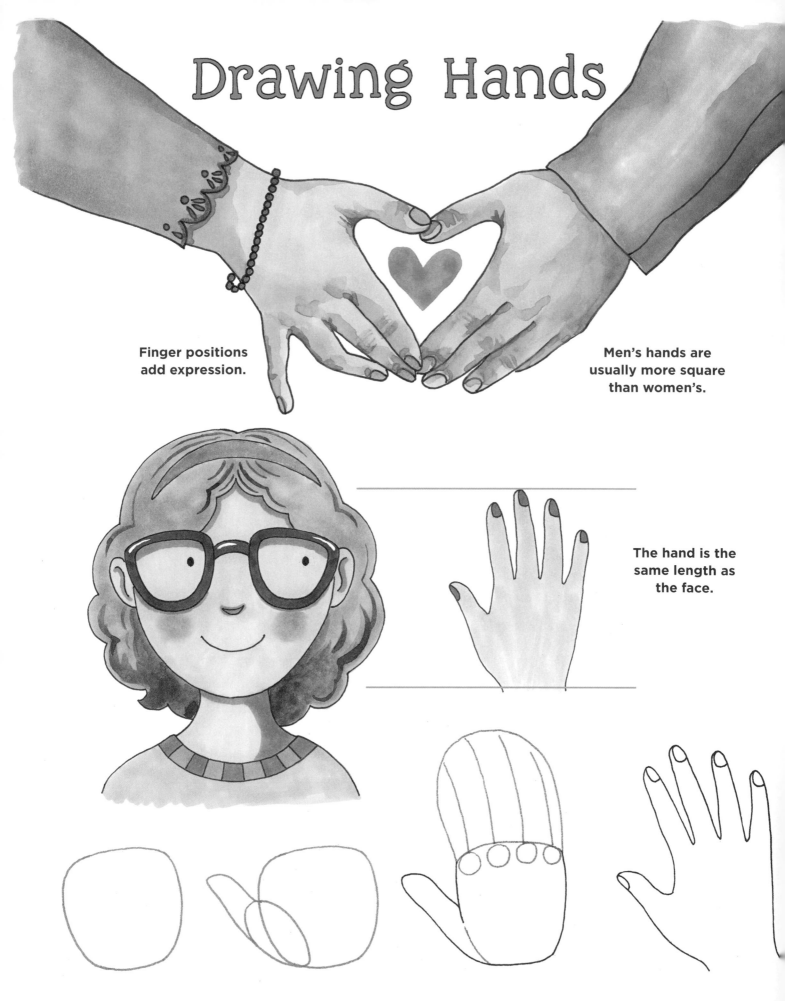

Finger positions add expression.

Men's hands are usually more square than women's.

The hand is the same length as the face.

DOODLE HANDS

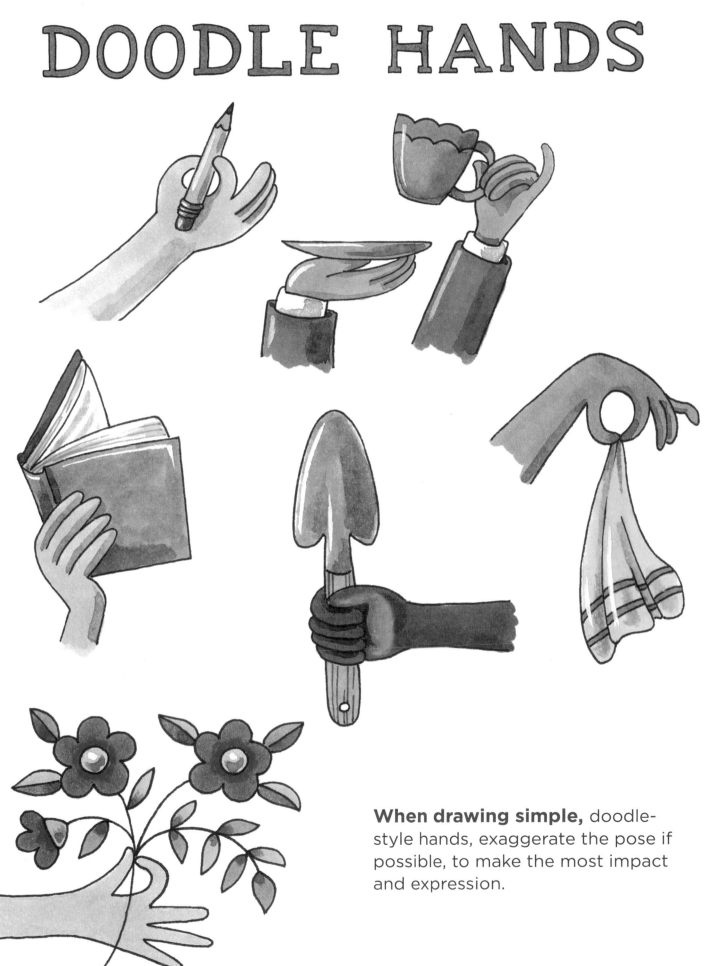

When drawing simple, doodle-style hands, exaggerate the pose if possible, to make the most impact and expression.

Drawing Realistic Hands

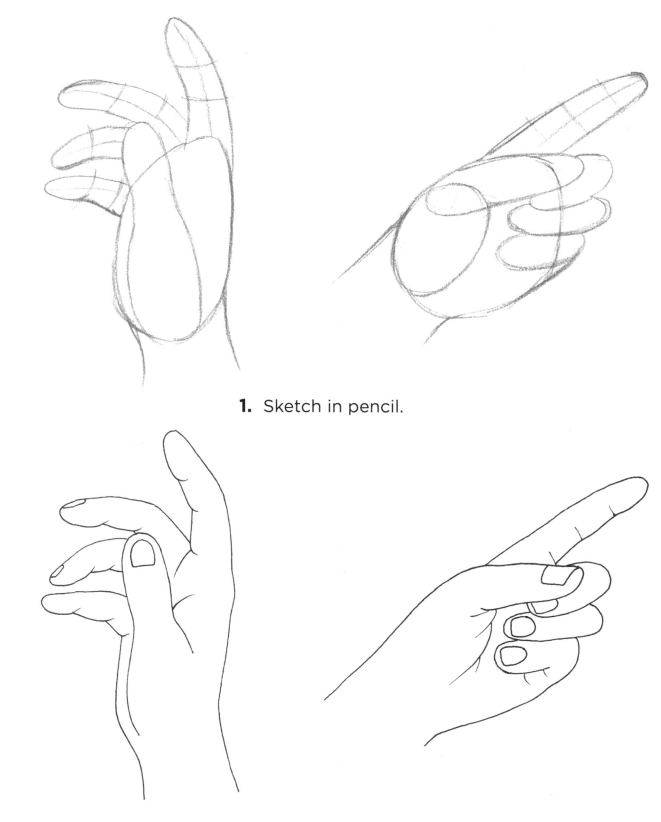

1. Sketch in pencil.

2. Ink the lines with a waterproof pen.

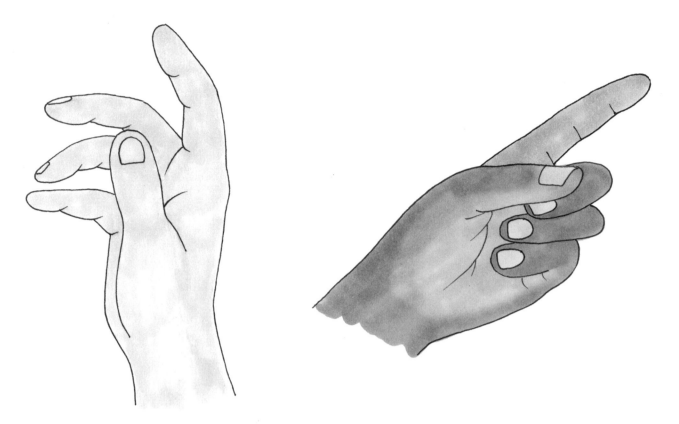

3. Fill in the base color with markers or watercolor. Hands with a darker skin tone have lighter-colored palms.

4. Add shading and details with watercolor. If desired, use white gouache for highlights.

DRAWING FLOWERS

When you first begin to draw flowers, they will probably look something like this: a basic center circle and five petals. Flowers have endless variety, though. By combining different centers and varying the shape and number of petals, you can create many types of flowers for your journal pages.

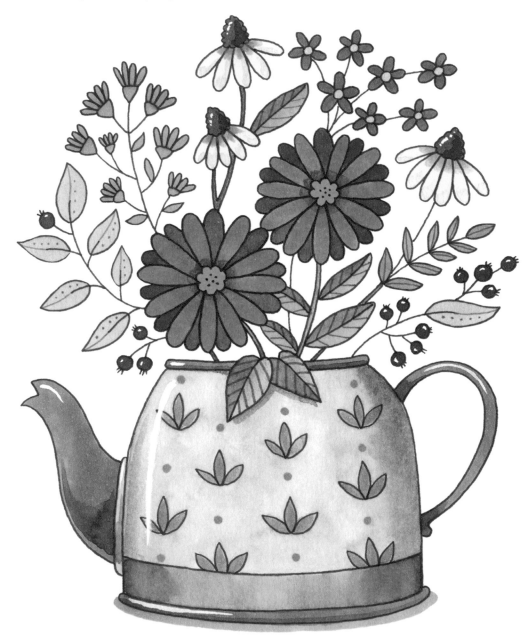

Here are some sample ways to doodle flowers. Draw with a pencil first, and make sure your pen is waterproof if you want to use markers to color them.

 Be sure to vary the sizes and shapes of the flowers and leaves.

1. Start with a flower center.

2. Choose a petal shape.

3. Choose a leaf shape.

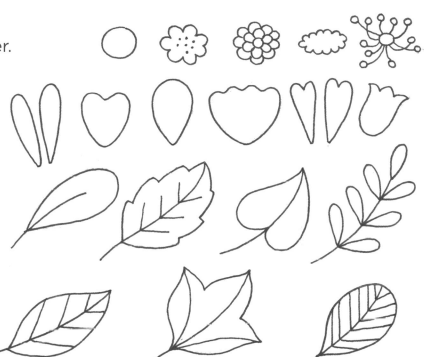

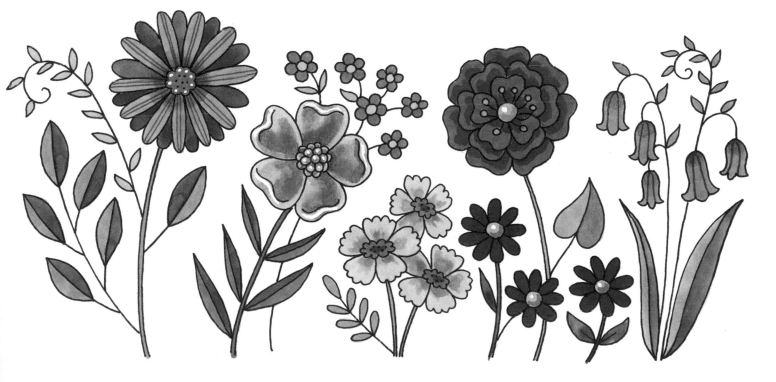

A flower is based on a circle, but to draw a flower that is turned away from you, the circle must become an ellipse. The petals become foreshortened. That is, they are flattened and shortened.

Leaves also show foreshortening as they rotate. The leaves stay the same length but become narrower.

Whether the petals are narrow or broad, they all need to be directed toward the center point.

Creating a Floral Composition

Here are a few things to keep in mind when drawing an interesting floral composition.

1. Vary the size of the leaves.

2. Draw several stages of the flower. Include buds or fruit.

3. Stems and other lines should be curved. There are no straight lines in nature.

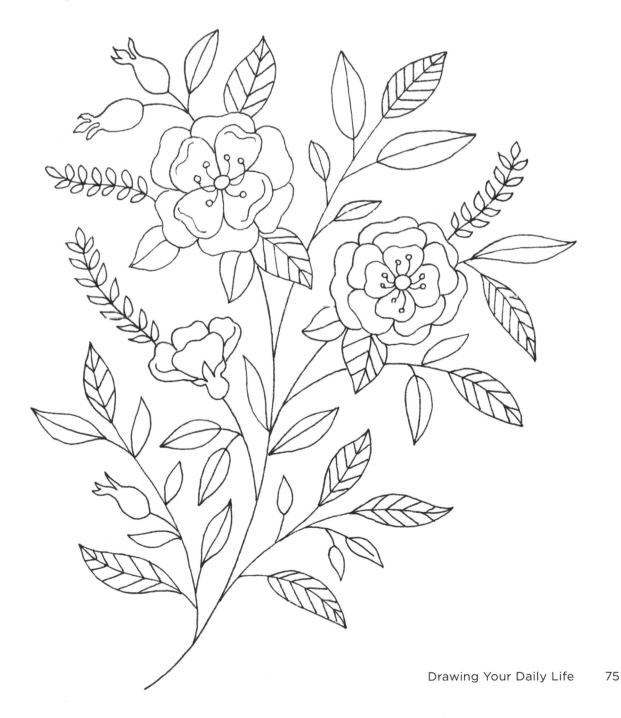

DRAWING TREES

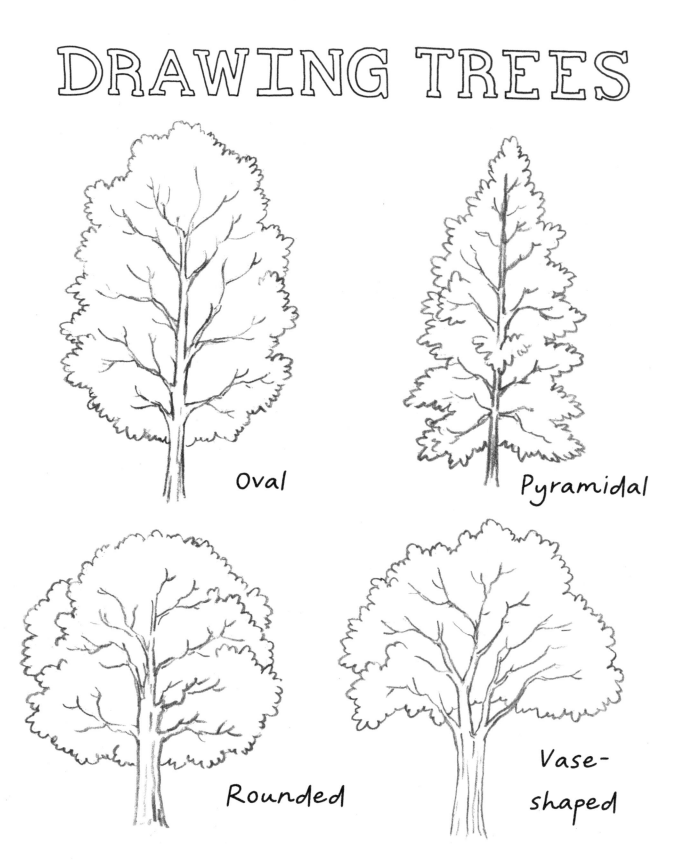

Oval

Pyramidal

Rounded

Vase-shaped

It's tempting to draw all trees as just a simple trunk with a ball on top, but your drawings will look better if you add variety and a more refined shape. There are several basic tree shapes to consider.

1. To draw a tree with markers, begin by lightly sketching the trunk with pencil. Then block in the rough shape of the foliage with a midtone green. Leave gaps where the sky shows through. The foliage is not a solid mass.

2. Draw the trunk with a warm gray marker. Place small twigs and branches throughout the gaps in the leaves. Erase the pencil marks.

3. With a slightly darker green marker, begin creating shadow areas in the foliage. Shade the trunk with a darker gray, making sure to be aware of the direction the light is coming from, so the shading is all on the same side.

4. Use your darkest markers to add the next layer. Define leaf shapes slightly by using smaller strokes in the foliage. Indicate bark texture on the trunk. You can stop here, or go on to add more detail in step 5.

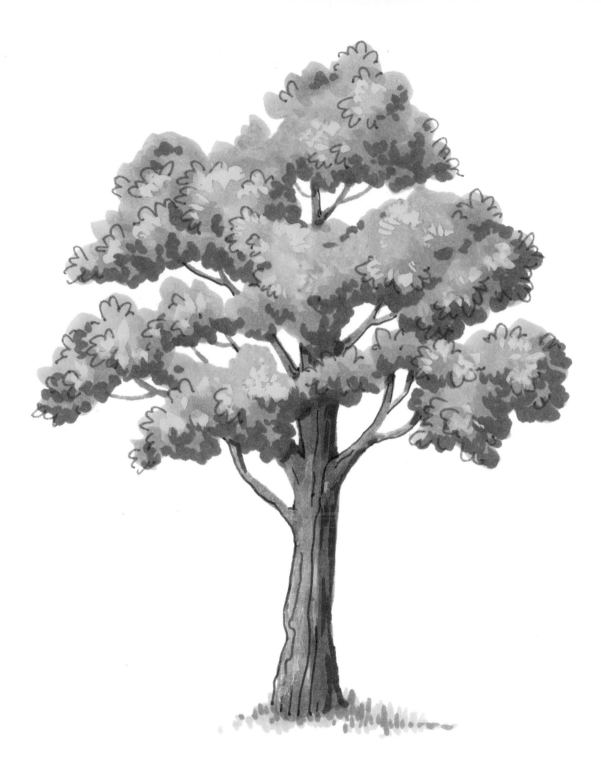

5. For the final step, add as many details as you like. I typically use a fine-point pen to add detail to the tree trunk and a few leaves in the foliage. It's nice to create some highlighted leaves with paint or a paint pen, but this is optional. Colored pencils are good for texture, if you prefer.

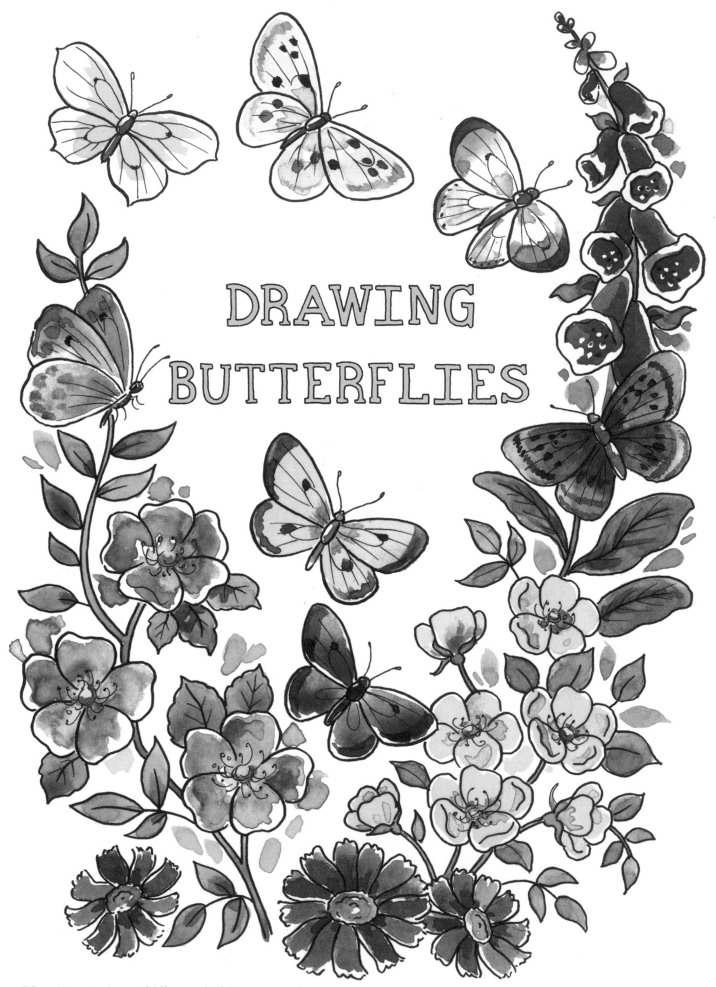

DRAWING BUTTERFLIES

DRAWING BUTTERFLIES
AND OTHER INSECTS

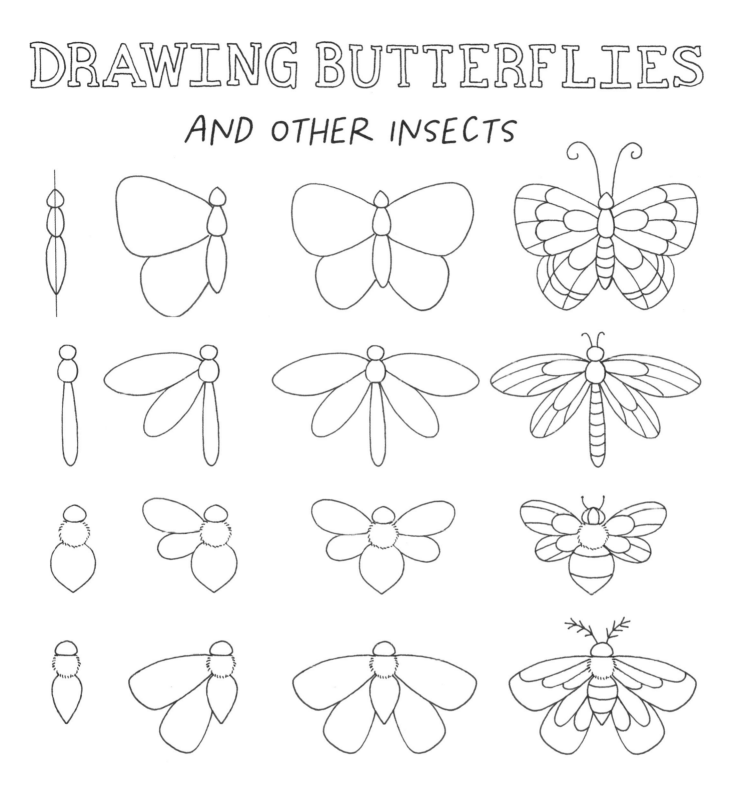

The key to drawing butterflies and other insects is symmetry. The right side is a mirror image of the left side. It can be helpful to draw one side, trace it, then flip the tracing over and transfer it onto the other side using graphite transfer paper. This is how I ensure that both sides are a good match.

DRAWING DOGS

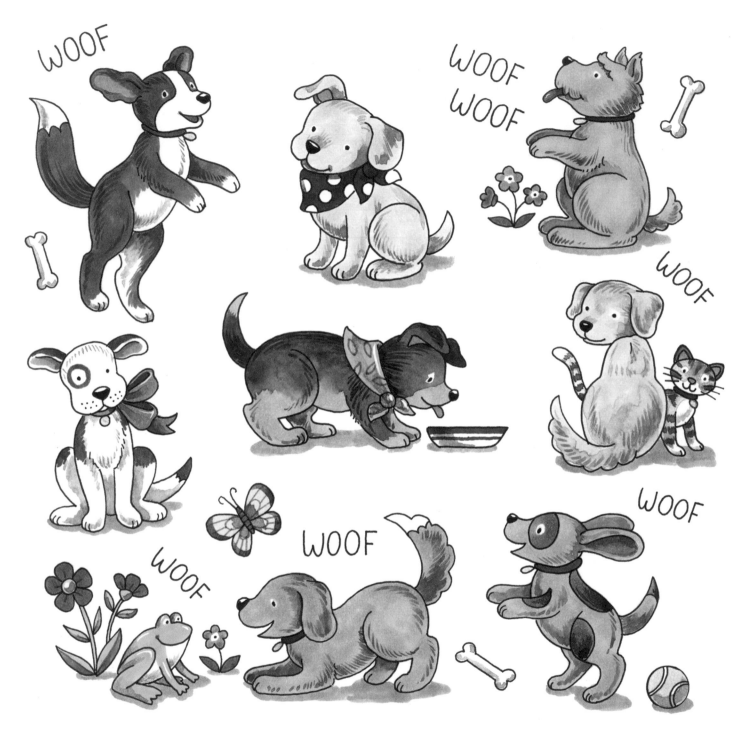

Pets are an important part of our lives, and they can be a charming addition to a journal page.

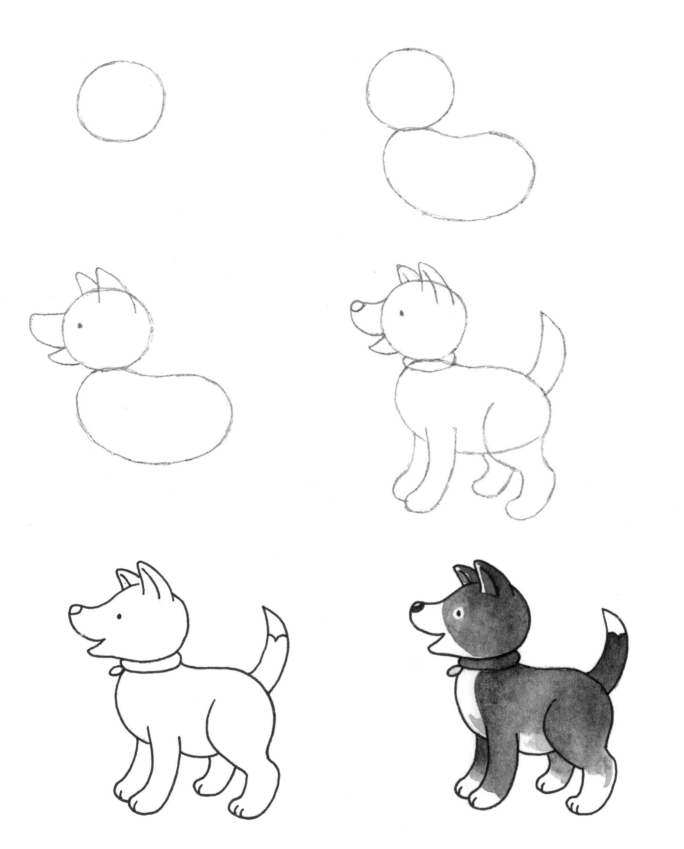

To draw a dog, begin with a pencil drawing of a circle, and add a peanut-shaped body. Next, add the eye, snout, and ears. Continue with the legs, making sure to use curved lines, not straight. Once you're satisified with your pencil drawing, ink the lines and erase the pencil marks. Add color as desired.

DRAWING CATS

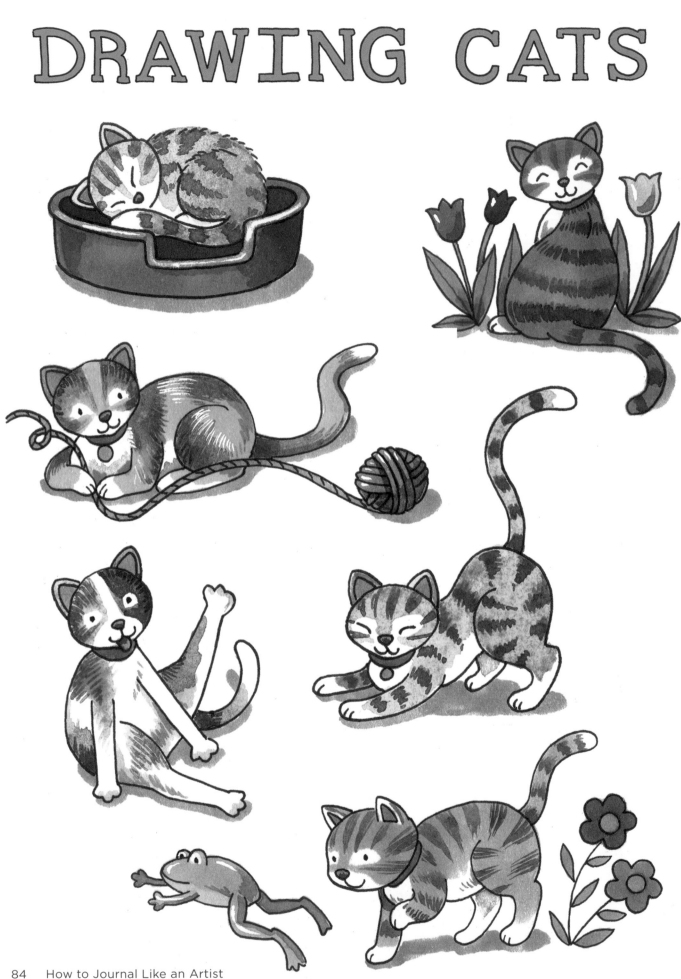

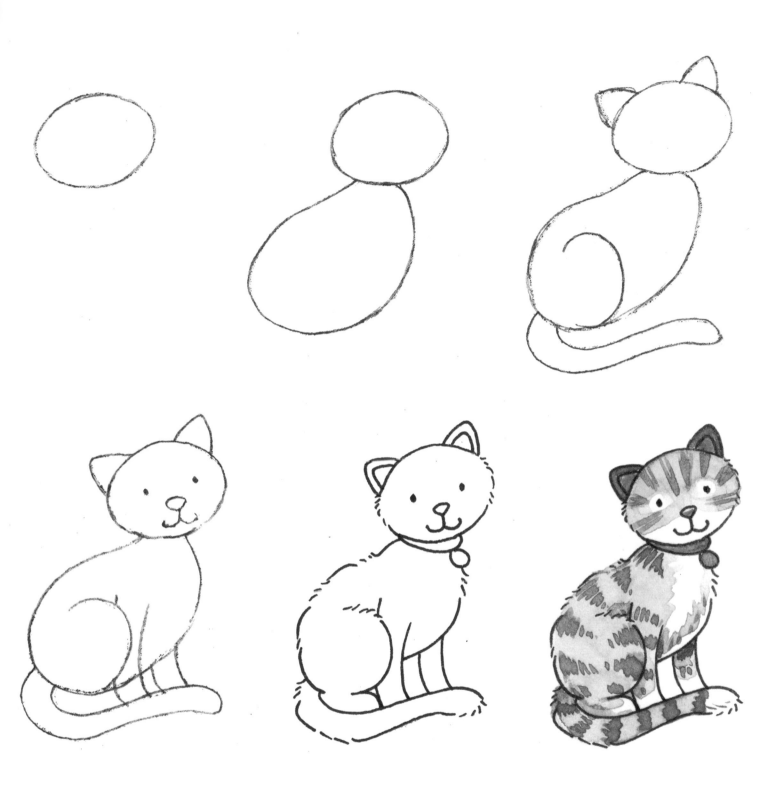

When drawing a fluffy animal like a cat, you don't need to make a solid outline around it. Try using some light, short strokes to indicate fur. I also like to add a collar when drawing pets, to simplify the problem of showing where the head attaches to the body.

DRAWING BIRDS

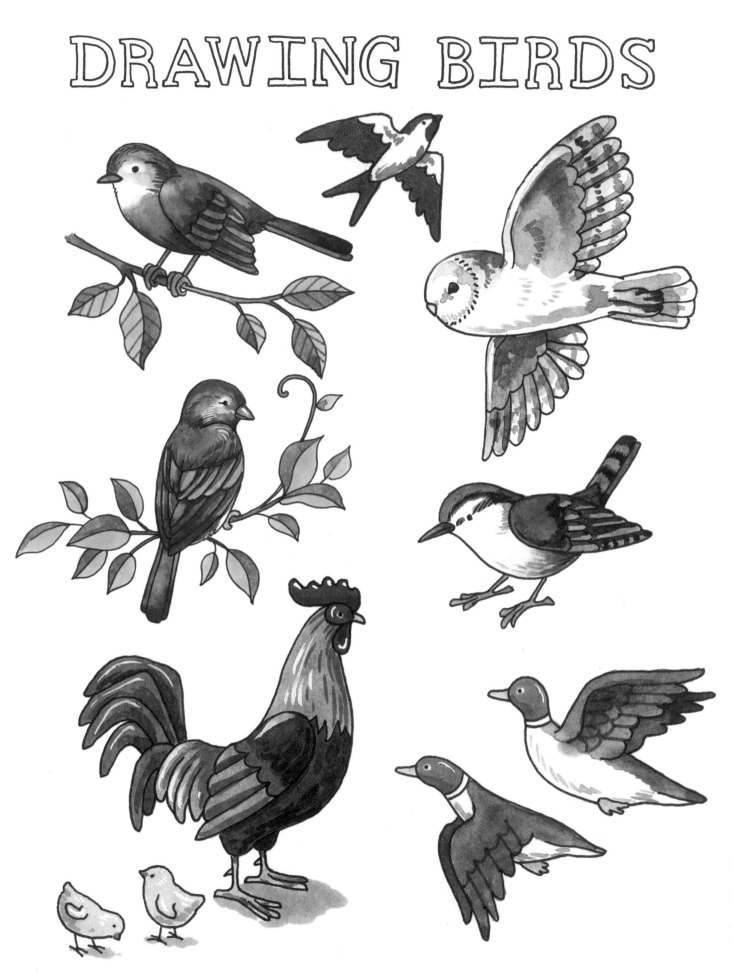

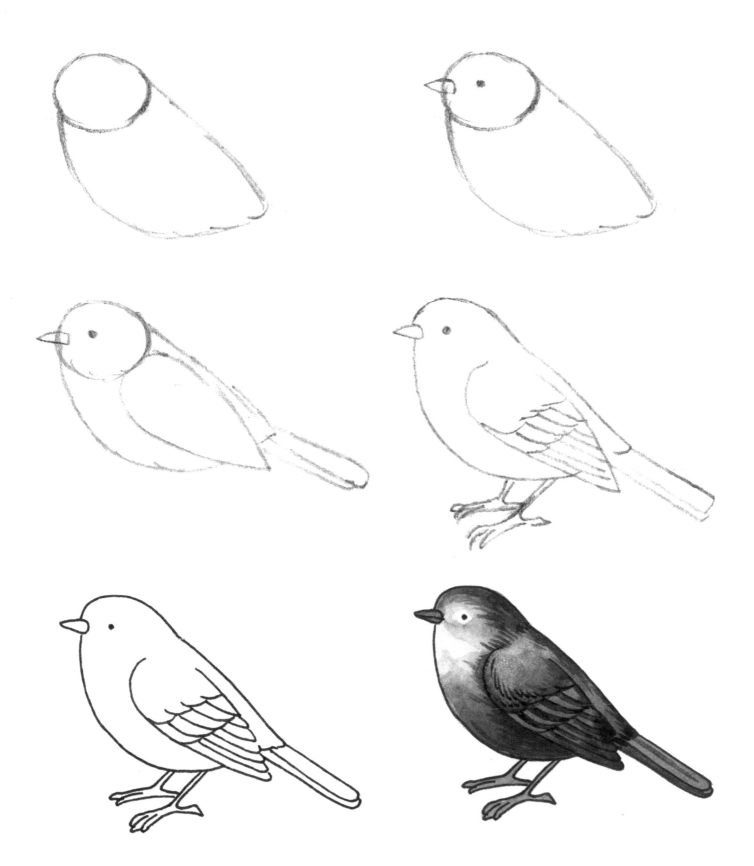

Songbirds can be very challenging to draw. The head nestles straight into the body, with no visible neck. The back feathers overlap the top of the tail. The legs are midway between the top of the head and the tip of the tail, so the bird is balanced.

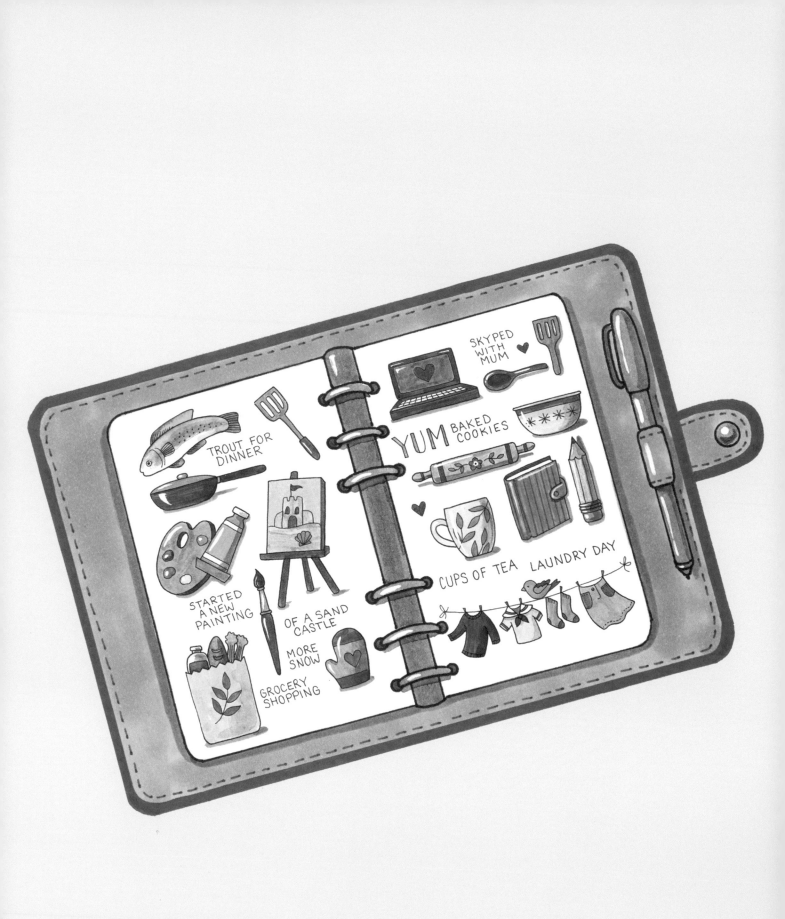

Chapter 5

Sketch Journal Techniques and Tips

Now that we've covered materials, creativity, art techniques, and how to draw common subjects, it's time to tie everything together. This chapter will walk you through putting a journal page together, step by step. You'll also get tips on hand-lettering, fixing mistakes, and more—plus great ideas for subjects and formats you might want to tackle in your own journal!

LETTERING TOOLS

For lettering, you really don't need much more than a pencil and eraser, but many people like to get more elaborate in their journals and sketchbooks.

I always start with a pencil, keeping my graphite lines light so they can be easily erased. A clear plastic ruler is helpful for creating guidelines. Working on grid paper can also help you achieve straight lettering.

Waterproof fineliners are my go-to for lettering, but I also like brush pens when I need a more varied line. Outlined letters can be filled in with markers or paint.

Experiment until you find the tools that work best for you. Seek out pens that can be purchased open stock, so you can try them without needing to buy a large set.

Here are some favorite fonts for you to try when laying out your journal pages.

Aa Bb Cc Dd Ee Ff Gg
Hh Ii Jj Kk Ll Mm Nn Oo
Pp Qq Rr Ss Tt Uu Vv
Ww Xx Yy Zz

ABCDEFGHIJKLM
NOPQRSTUVWXYZ

ABCDEFGHIJK
LMNOPQRSTU
VWXYZ

Lettering Steps

FEELING thankful

1. Sketch with a pencil.

FEELING thankful

2. Ink the lines with a fineliner pen.

FEELING thankful

3. Add color when desired.

thankful EVERY DAY

Try experimenting with different font styles. You can mix fonts or add elements like banners.

GIVE YOURSELF
PERMISSION
TO TAKE AN
INTERMISSION

A CUP OF TEA WITH FRIENDS

SPEND TIME OUTDOORS

TAKE A NAP

READ A GOOD BOOK

IT IS OKAY TO REST

It's a challenge to get lettering just right, and too much erasing can damage the surface of the paper. For this reason, I like to work out my lettering on a sheet of tracing paper first. The drawing can then be transferred to the page with graphite transfer paper—just put a sheet of graphite paper between the journal page and the tracing paper and trace your lines with a pencil or pen. They'll be transferred onto the journal page in graphite as if you drew them with a pencil.

GIVE YOURSELF **PERMISSION** TO TAKE AN **INTERMISSION**

A CUP OF TEA WITH FRIENDS

SPEND TIME OUTDOORS

TAKE A NAP

READ A GOOD BOOK

IT IS OKAY TO REST

Once you've transferred the drawing from the tracing paper, ink the lines with a fineliner pen. Once the ink is dry, erase the graphite.

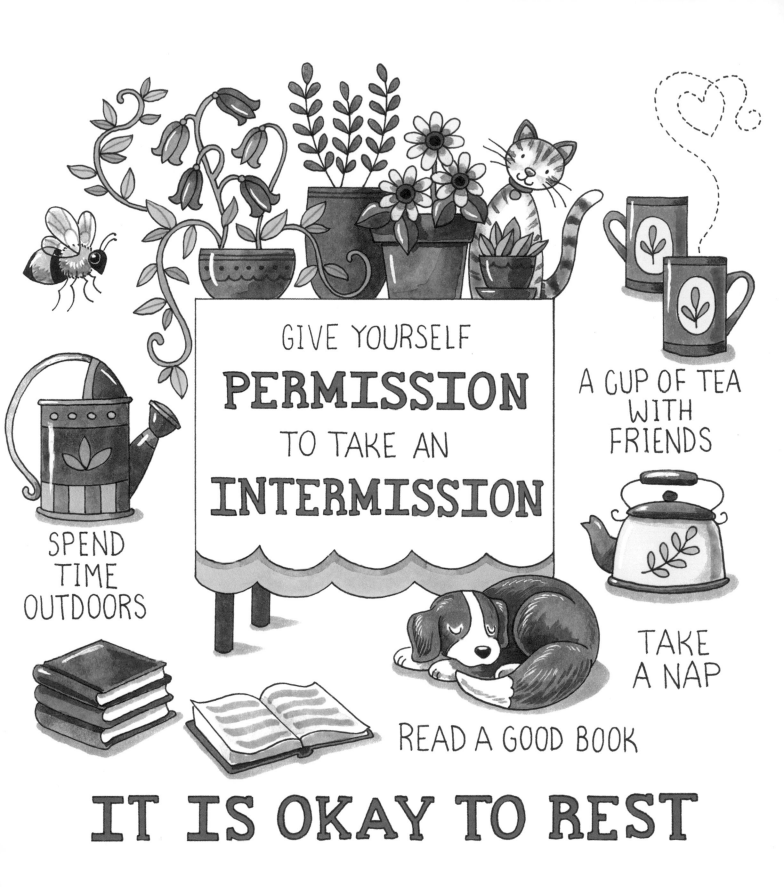

GIVE YOURSELF

PERMISSION

TO TAKE AN

INTERMISSION

A CUP OF TEA WITH FRIENDS

SPEND TIME OUTDOORS

TAKE A NAP

READ A GOOD BOOK

IT IS OKAY TO REST

Now it's time to add color. Let yourself enjoy the process, without worrying about perfection.

BIRTHDAYS

Consider adding shadows to your lettering. A shadow can give your lettering dimension and help lift it from the page. Shadowed lettering is best used for captions and headers because it bestows so much emphasis.

Block letters are great for adding art, color, and decorations. Try pairing the large letters with thin, delicate ones.

BANNERS AND FRAMES

Banners and frames are nice decorative elements to add to captions and important words on your pages.

Banners are good for titles. You can purchase plastic templates to help with shapes.

You can elongate or compress your lettering to match the length of your banners.

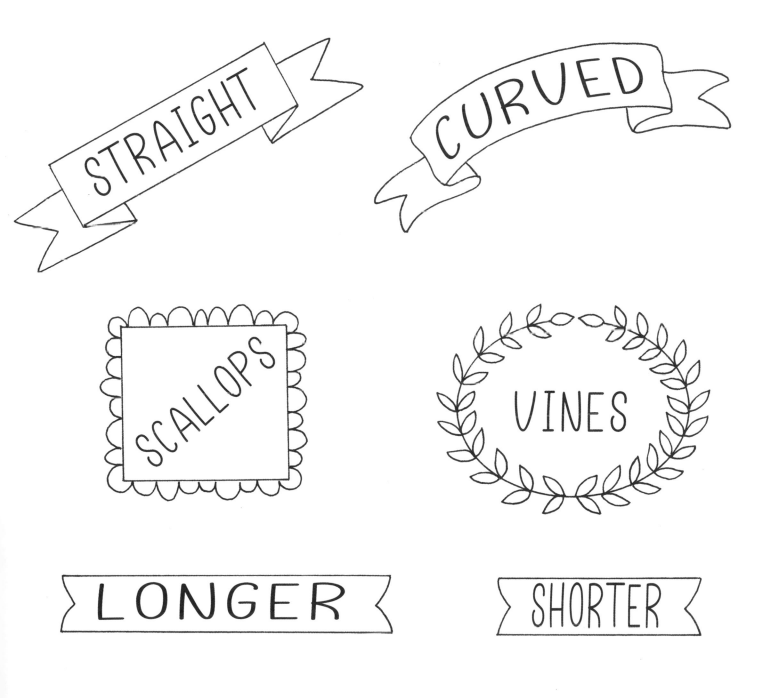

ADDING BORDERS

A whimsical or colorful border can add a charming touch to your pages and help pull the composition together. On this page I've given some examples of cute borders that you can use in your journal. I find that it works best to lay your border out with a pencil and clear ruler. Make sure that each side of your border is an equal distance from the edge of the page. Can you think of other border designs?

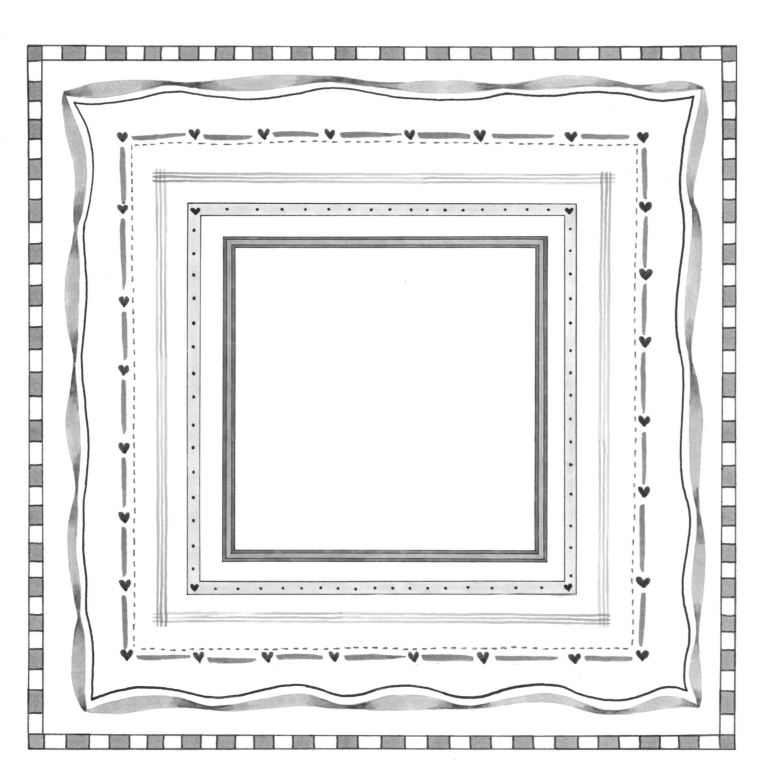

Here are more border designs for your journal. Feel free to copy them or even cut them out to paste into your own journal.

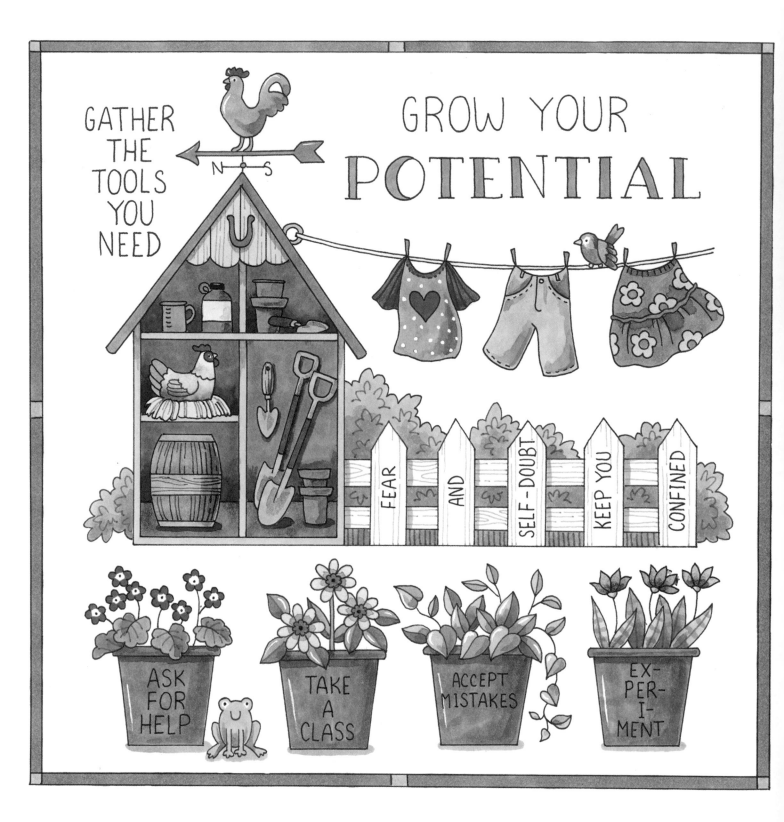

Adding lettering in the white spaces around your drawing may seem like an obvious solution, but consider placing the lettering within the drawing itself. The fence posts and plant pots here were a perfect choice for placing text.

Feel free to use a variety of fonts or lettering styles on your journal pages. Remember, this is hand lettering, and the fact that it's not perfect is just part of the charm.

FIXING MISTAKES

We all make mistakes. It makes my heart sink to work hard on a page and then spoil it! I drew and inked the page shown below, but I really didn't like how the teapot looked. Here's how I fixed it.

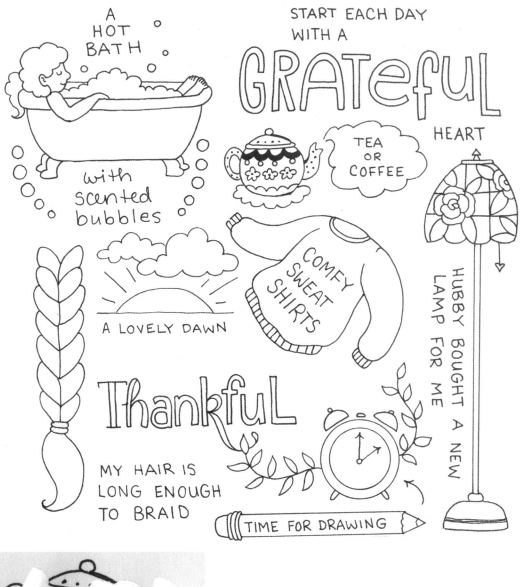

A HOT BATH

with scented bubbles

START EACH DAY WITH A

GRATEFUL

TEA OR COFFEE

HEART

A LOVELY DAWN

COMFY SWEAT SHIRTS

HUBBY BOUGHT A NEW LAMP FOR ME

Thankful

MY HAIR IS LONG ENOUGH TO BRAID

TIME FOR DRAWING

1. First, I painted over the drawing with opaque white paint. I used gouache, but acrylic works too.

2. I drew a new teapot and carefully cut it out. Then I glued it to the page.

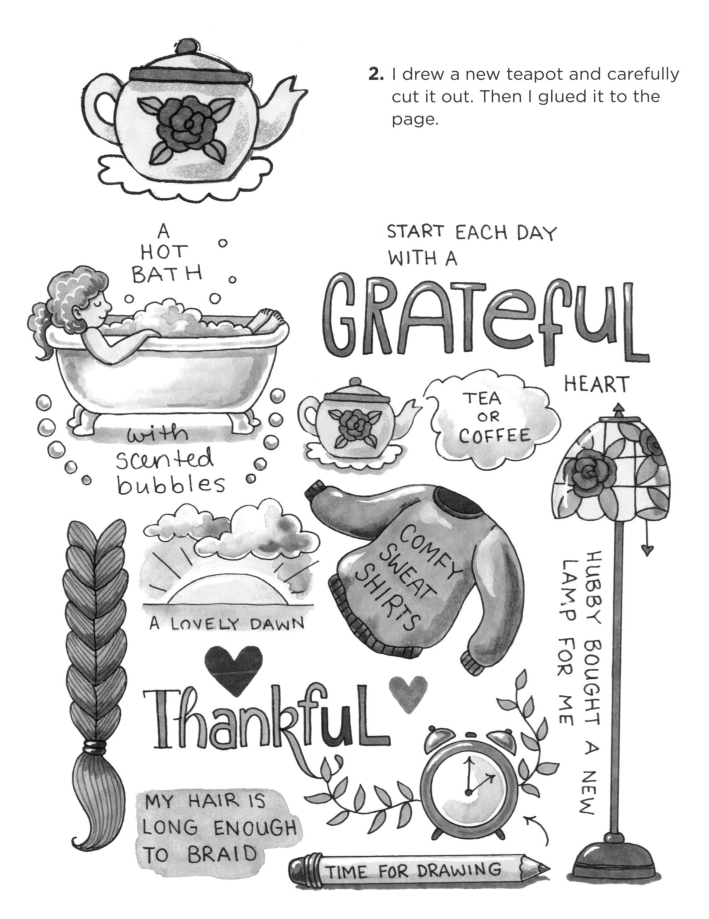

A HOT BATH

START EACH DAY WITH A

GRATEFUL

HEART

with scented bubbles

TEA OR COFFEE

A LOVELY DAWN

COMFY SWEAT SHIRTS

HUBBY BOUGHT A NEW LAMP FOR ME

Thankful

MY HAIR IS LONG ENOUGH TO BRAID

TIME FOR DRAWING

Once the page is finished, the pasted-in area is barely noticeable.

MAKING PERSONAL MAPS

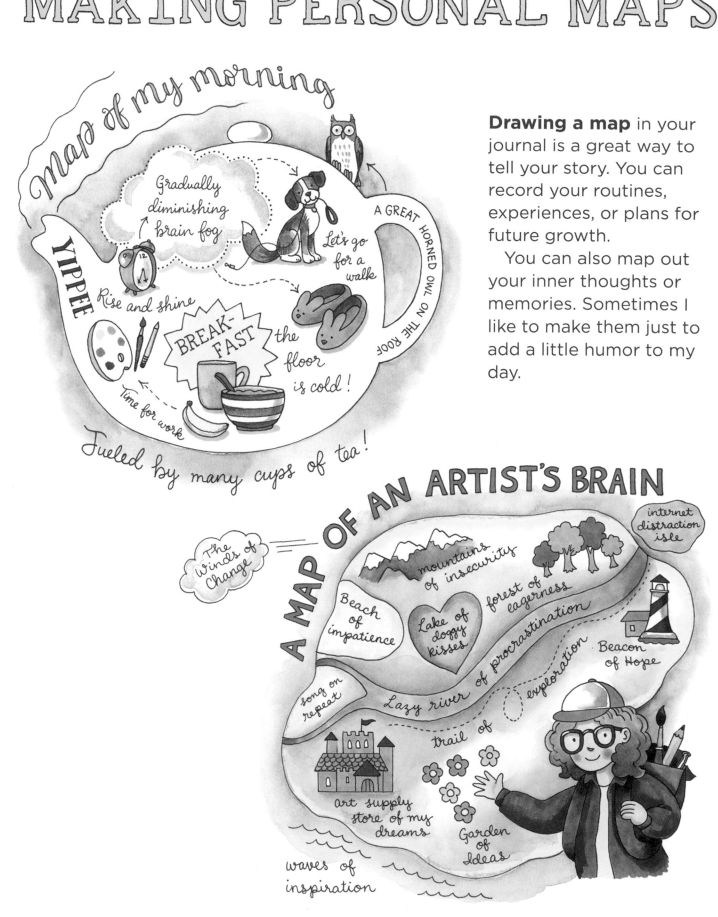

Map of my morning

YIPPEE

Rise and shine

Gradually diminishing brain fog

Let's go for a walk

A GREAT HORNED OWL ON THE ROOF

BREAK-FAST

the floor is cold!

Time for work

Fueled by many cups of tea!

Drawing a map in your journal is a great way to tell your story. You can record your routines, experiences, or plans for future growth.

You can also map out your inner thoughts or memories. Sometimes I like to make them just to add a little humor to my day.

A MAP OF AN ARTIST'S BRAIN

The Winds of Change

internet distraction isle

mountains of insecurity

forest of eagerness

Beach of impatience

Lake of doggy kisses

Lazy river of procrastination

trail of exploration

Beacon of Hope

song on repeat

art supply store of my dreams

Garden of Ideas

waves of inspiration

THINKING IN PICTURES

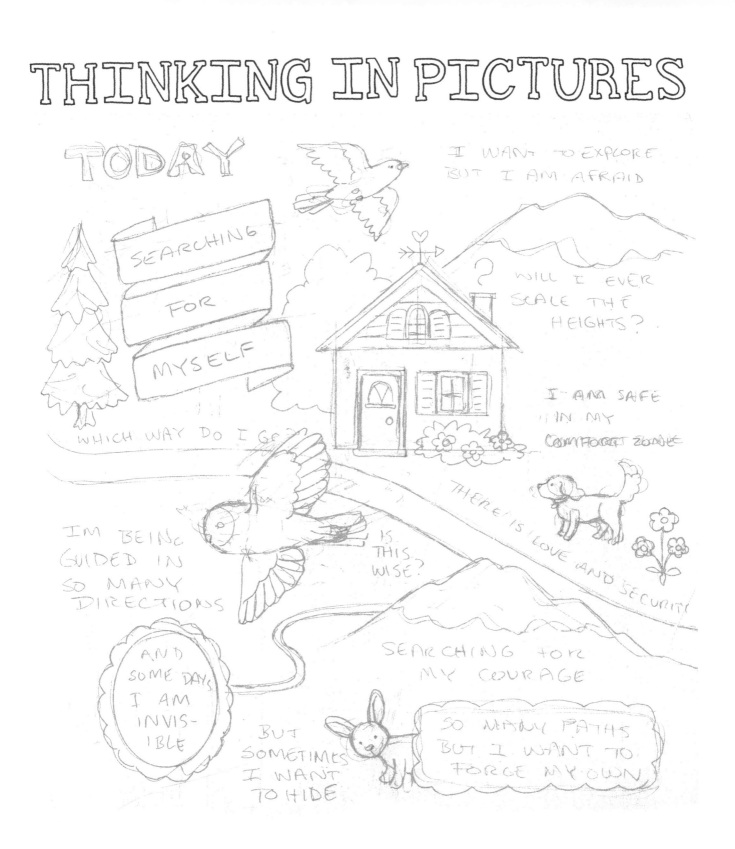

A map can be an illustrated narrative of your inner thoughts. I make them in my journal as a type of mindfulness exercise. A map does not need to be a guide to a specific location. Maps of your thoughts are sometimes referred to as "mind maps."

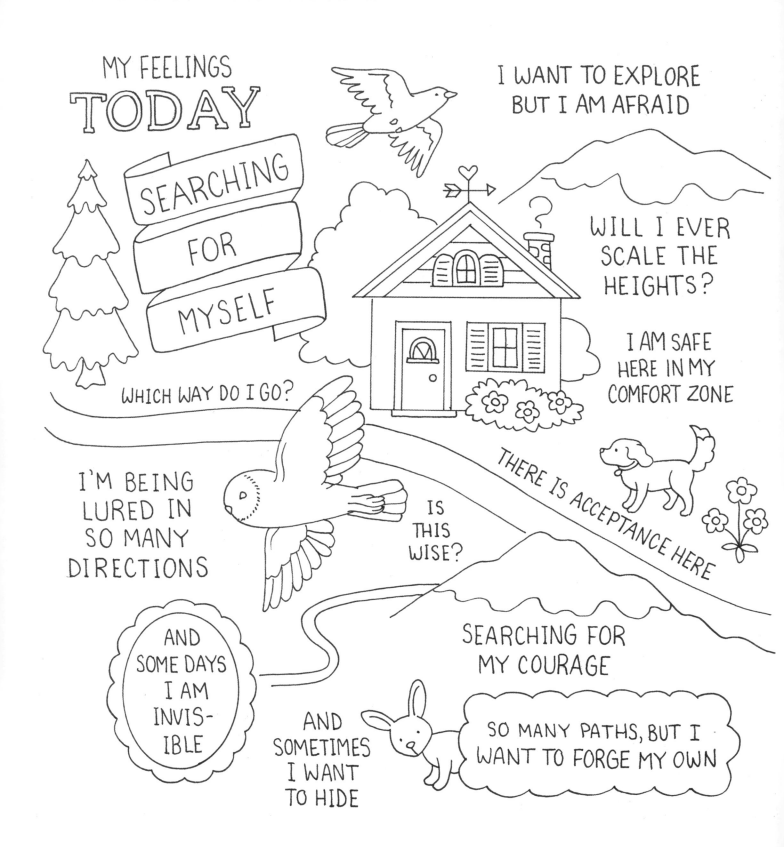

I generally start in the top left corner of the page and let the writing and art flow down the page. On these pages, I consider the written word first, and then think which images illustrate those thoughts.

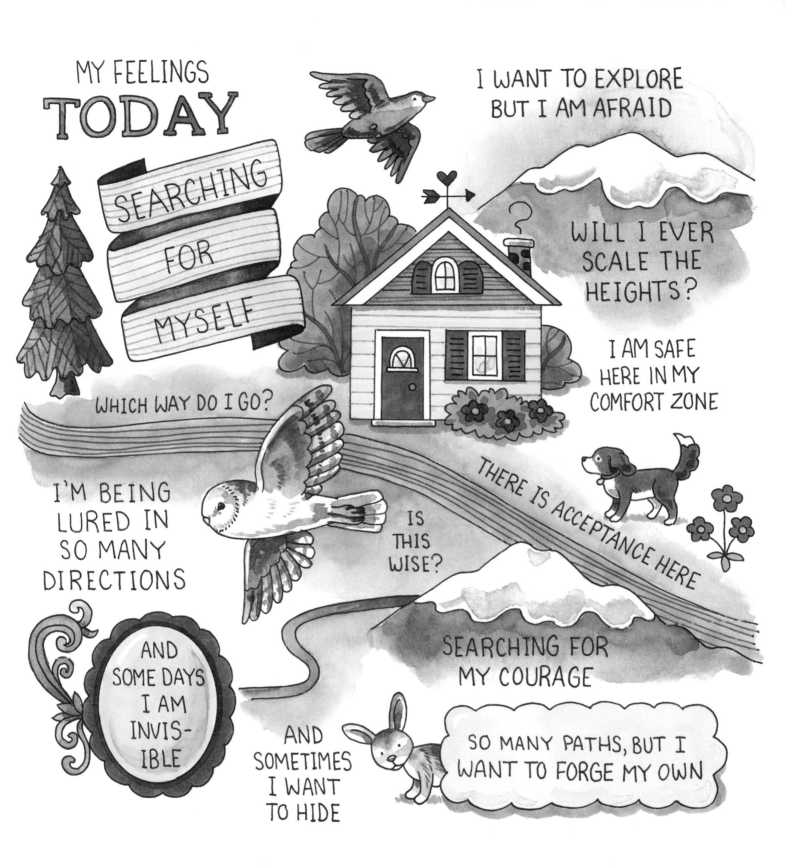

I tend toward color palettes that are bright and cheerful, even when my moods are low. Color makes a huge impact on mood, and making bright choices lifts my spirits.

A MAP OF YOUR HAND

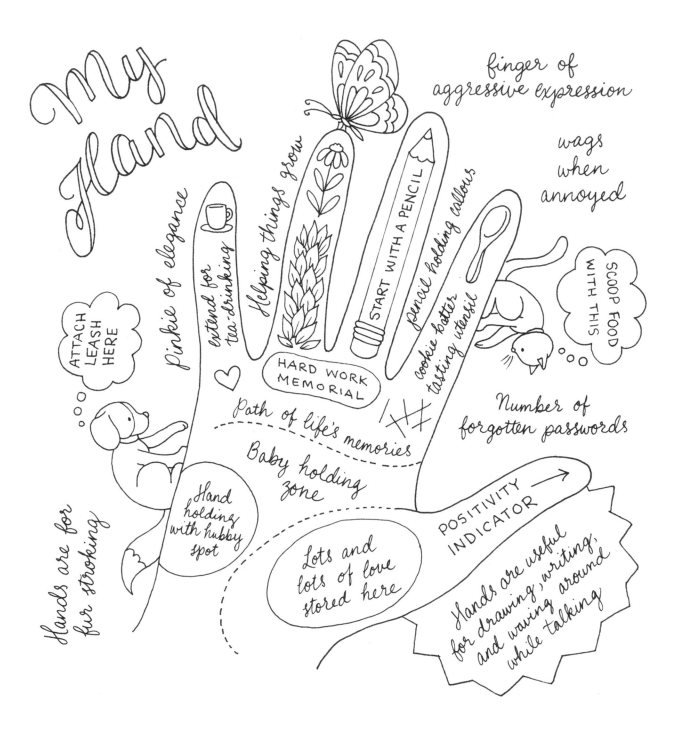

My Hand

finger of aggressive expression

wags when annoyed

Helping things grow

START WITH A PENCIL

Pencil holding callous

cookie batter tasting utensil

SCOOP FOOD WITH THIS

Pinkie of elegance

extend for tea-drinking

ATTACH LEASH HERE

HARD WORK MEMORIAL

Path of life's memories

Baby holding zone

Number of forgotten passwords

Hands are for fur stroking

Hand holding with hubby spot

Lots and lots of love stored here

POSITIVITY INDICATOR

Hands are useful for drawing, writing, and waving around while talking

The hand is the symbol of the self. Have you ever seen palmistry charts that purport to show your future in the palm of your hand? Making a map of your hand is a good exercise in focusing on what makes you the person you are.

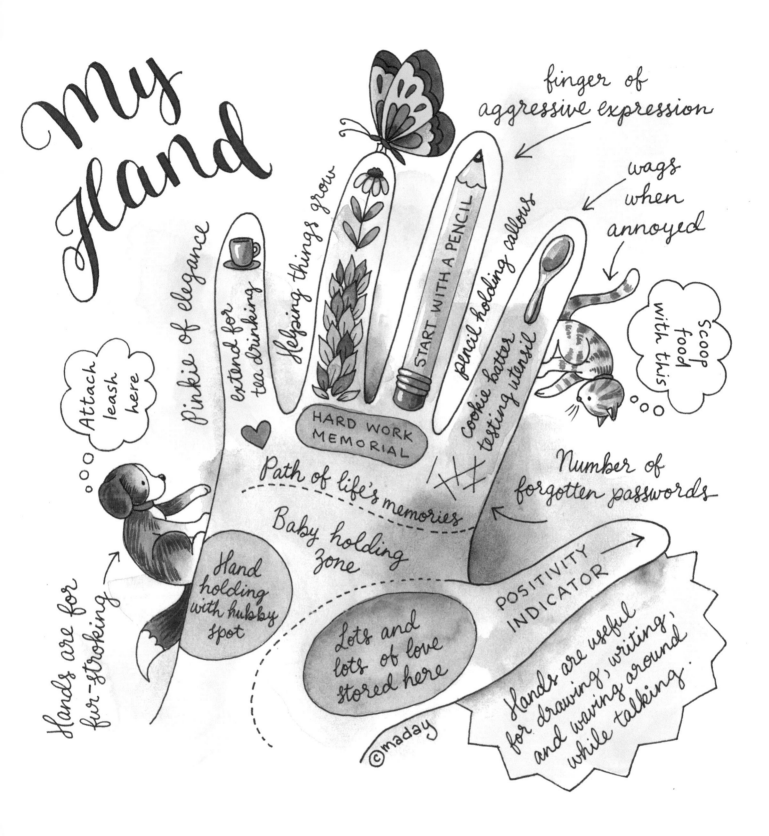

Think about the things and experiences that define you. For me, when I think of my hands, I think of holding both babies and paintbrushes, symbols of family and career.

DRAWING LOCATION MAPS

A hand-drawn map of a special location can be a nice memento. Begin by drawing the layout of the roads and landmarks like rivers and lakes. The internet is a great place to research this.

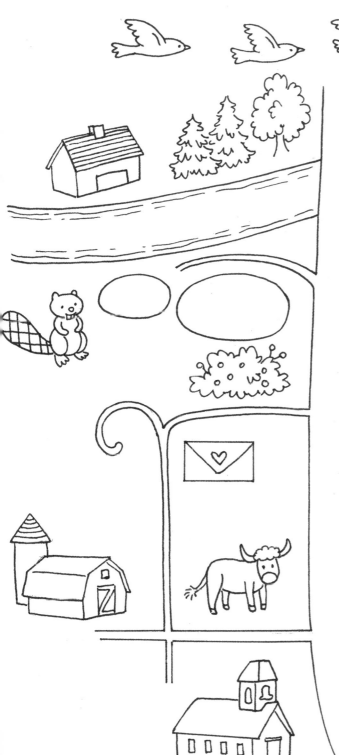
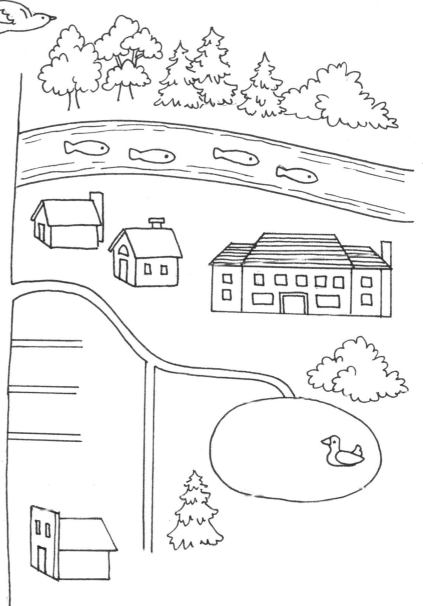

Next, fill in the map with simple drawings of the special locations. I have a special memory of visiting the beaver ponds and picking berries at the park, so I made sure to include those.

It's okay if your map is not completely accurate! A map in your journal is for recording special memories, not for navigation.

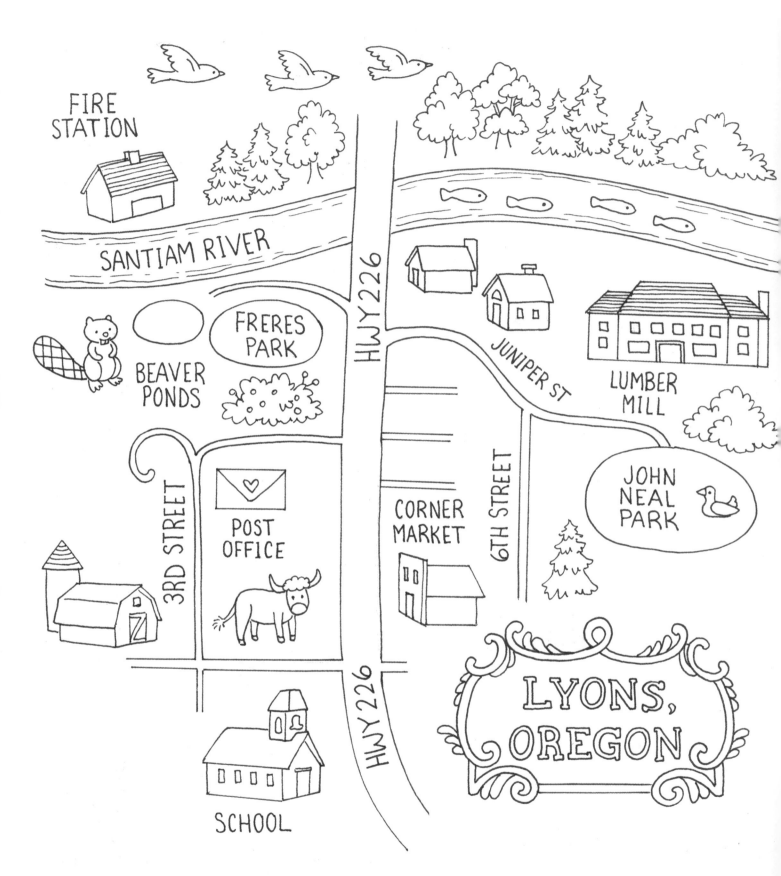

Label the roads and places of interest. I like to make an elaborate title for my maps. This type of fancy, framed title is called a cartouche.

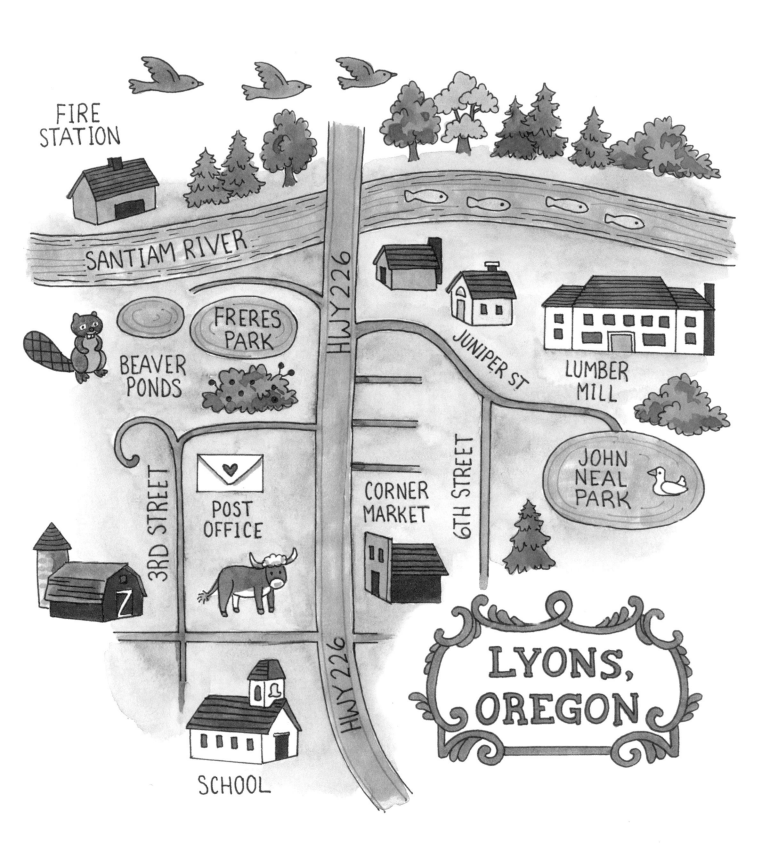

Add color with watercolor or markers. Keep the color simple, so it doesn't overwhelm the small images.

Gratitude JOURNALING

WRITE AT LEAST 3 THINGS

bedtime is a good time to do this

Consider making a gratitude jar that you can fill with small notes of thankfulness.

Practicing gratitude for one month can rewire your brain and give you a more optimistic outlook.

TAKE TIME TO APPRECIATE LIFE ♥

GRATITUDE HELPS US TO MAKE PEACE WITH OUR PAST AND CREATES A POSITIVE VISION FOR THE FUTURE.

Focusing on gratitude helps create a positive worldview. It can strengthen relationships and remind you of what's important.

Today I am grateful for:

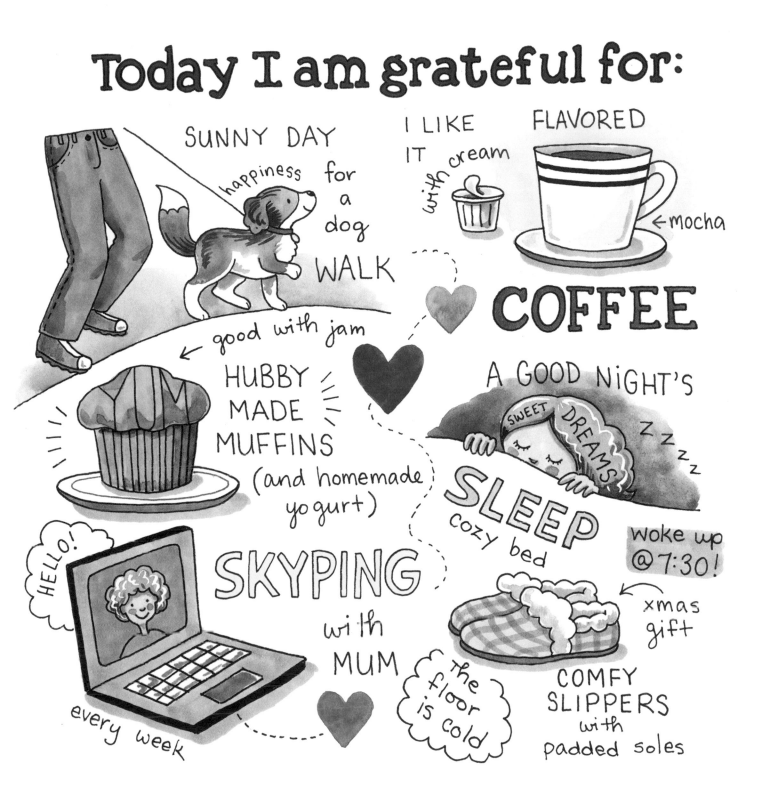

Practicing daily gratitude can reduce blood pressure, benefit your immune system, and have a therapeutic effect. Simply jot down a few items each day that made you happy. Your pages can be as simple or as complex as you like. Focus on each day and the pleasures you experience.

GRATEFUL MEMORIES
OF A BELOVED AUNT

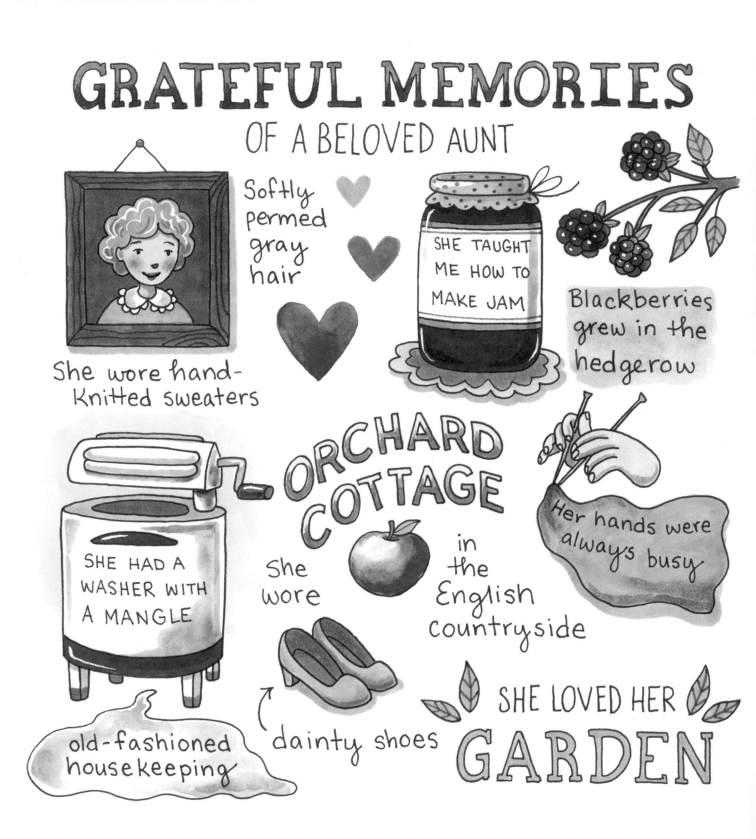

Softly permed gray hair

She wore hand-knitted sweaters

SHE TAUGHT ME HOW TO MAKE JAM

Blackberries grew in the hedgerow

SHE HAD A WASHER WITH A MANGLE

ORCHARD COTTAGE

She wore

in the English countryside

Her hands were always busy

old-fashioned housekeeping

dainty shoes

SHE LOVED HER GARDEN

A journal is the perfect place to store special memories of loved ones. Consider making tribute pages of the important people in your life. Lately, I've made sure to share my pages with their subjects while I still can.

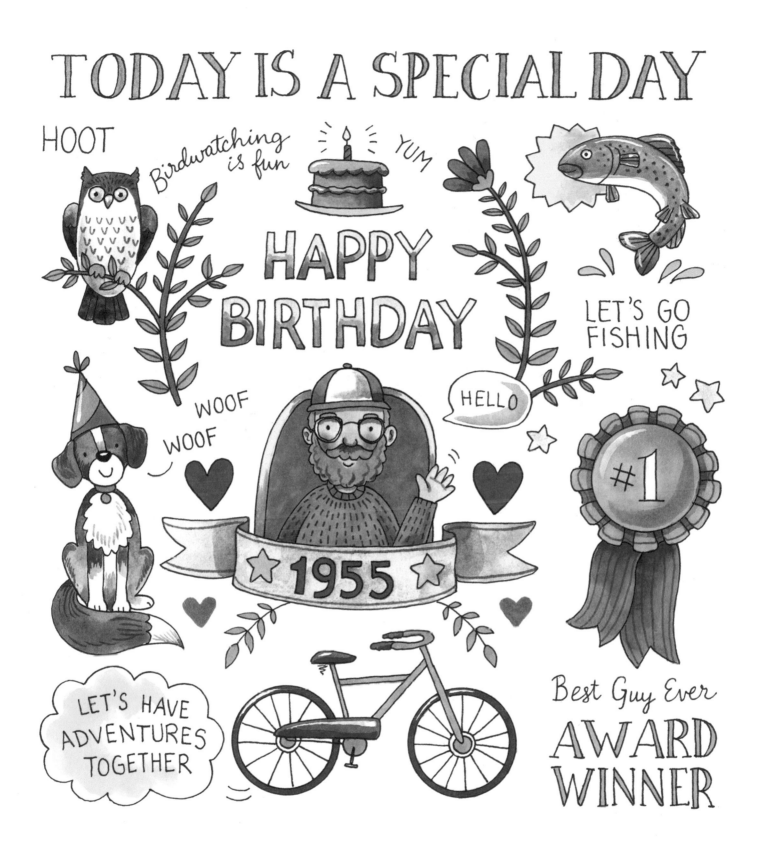

A tribute page can also focus on one special day in your subject's life. Birthdays, anniversaries, and graduations are all important moments. These pages can make touching gifts.

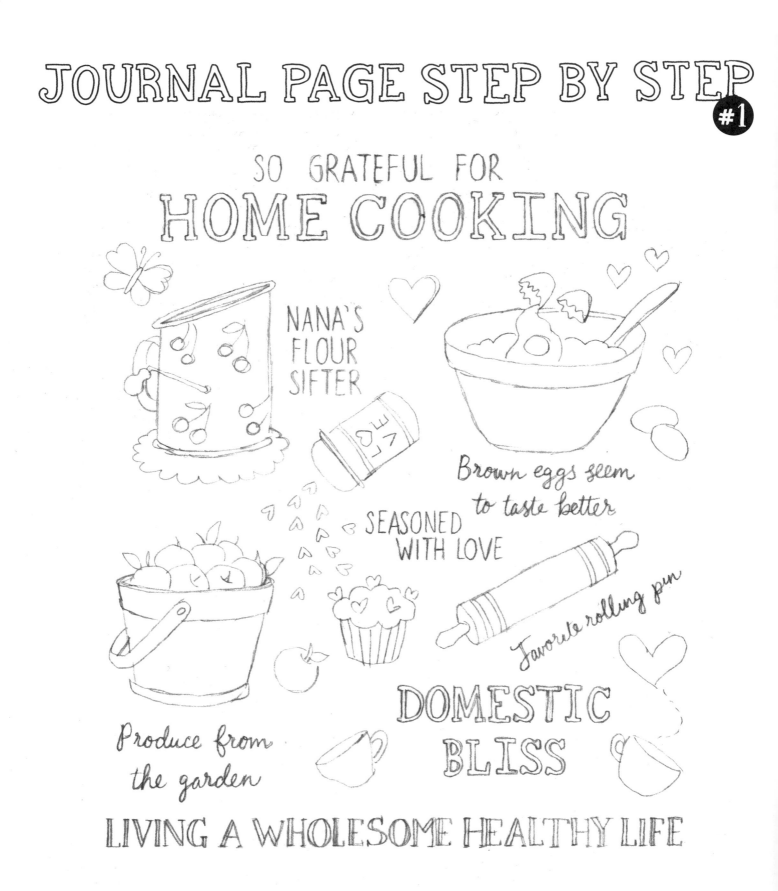

SO GRATEFUL FOR
HOME COOKING

NANA'S FLOUR SIFTER

LOVE

Brown eggs seem to taste better

SEASONED WITH LOVE

Favorite rolling pin

Produce from the garden

DOMESTIC BLISS

LIVING A WHOLESOME HEALTHY LIFE

Step 1: When creating an elaborate journal page, I start with a pencil sketch. Sometimes I plan the whole thing on tracing paper, then transfer it to my journal with graphite paper.

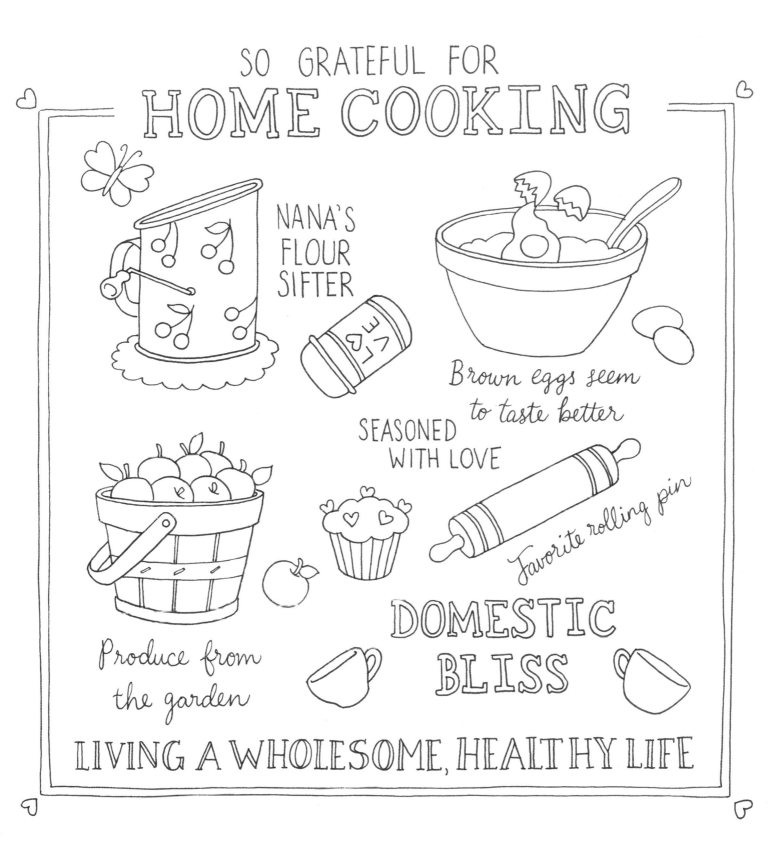

Step 2: Once the drawing has been transferred, I go over the lines with a waterproof fineliner pen. Make sure the ink is completely dry before erasing the pencil lines.

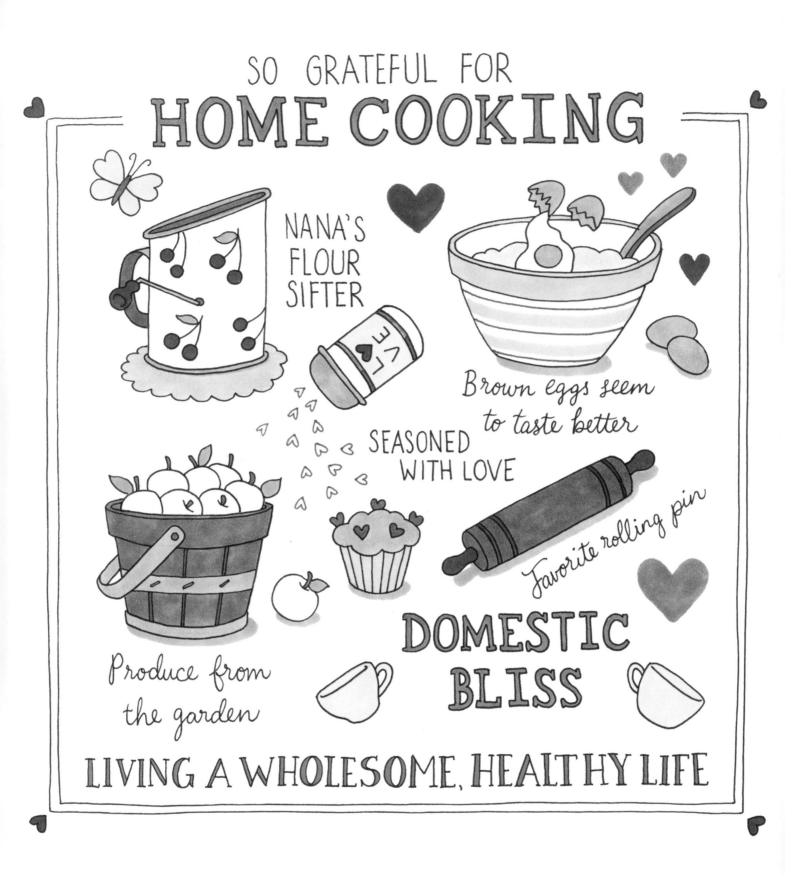

Step 3: After the ink is dry, it's time to add the base colors with watercolors or markers.

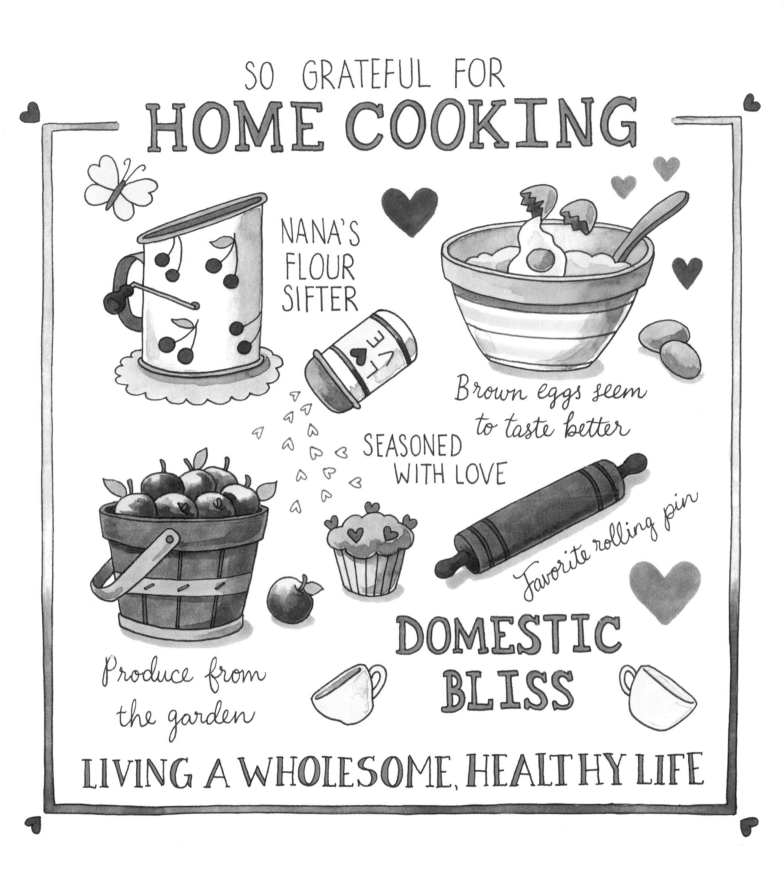

Step 4: Next, add the shading. Use watercolor, colored pencil, or markers.

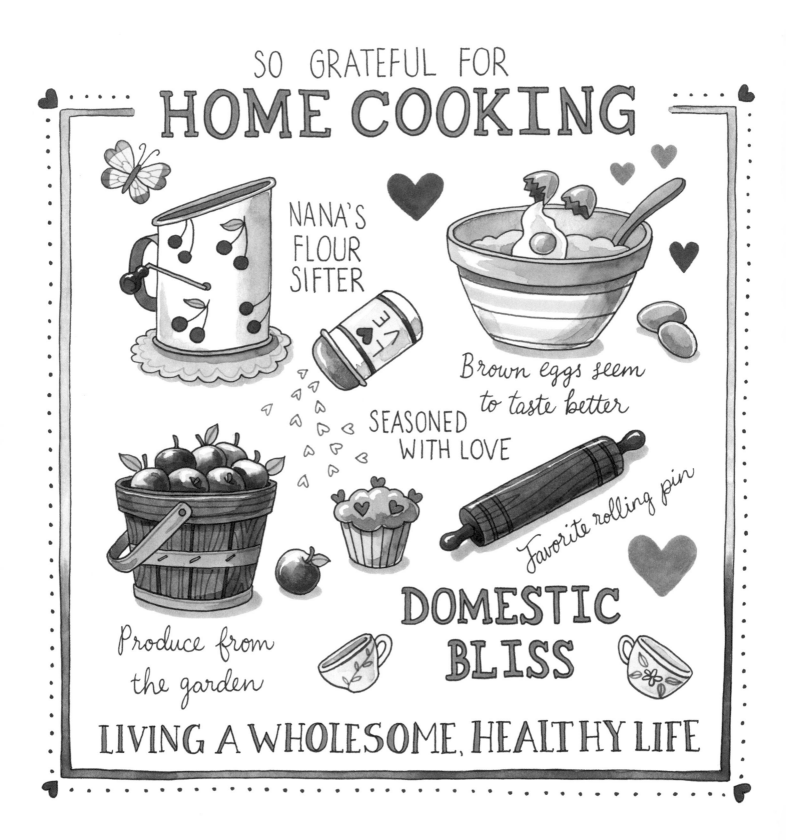

Step 5: The final stage is to add highlights. I like to use white gouache and a small brush, but a white paint pen is also good. Fine details like the wood grain were drawn with a waterproof colored fineliner pen.

JOURNAL PAGE STEP BY STEP

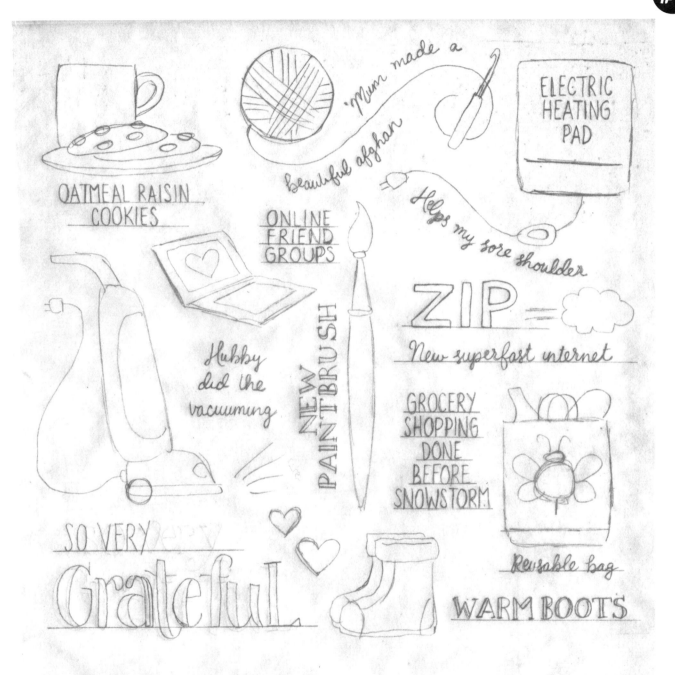

Step 1: This gratitude journal page has a lot of lettering. I drew guidelines to help make sure the lettering was relatively straight. The tracing paper method is especially useful when dealing with large blocks of lettering.

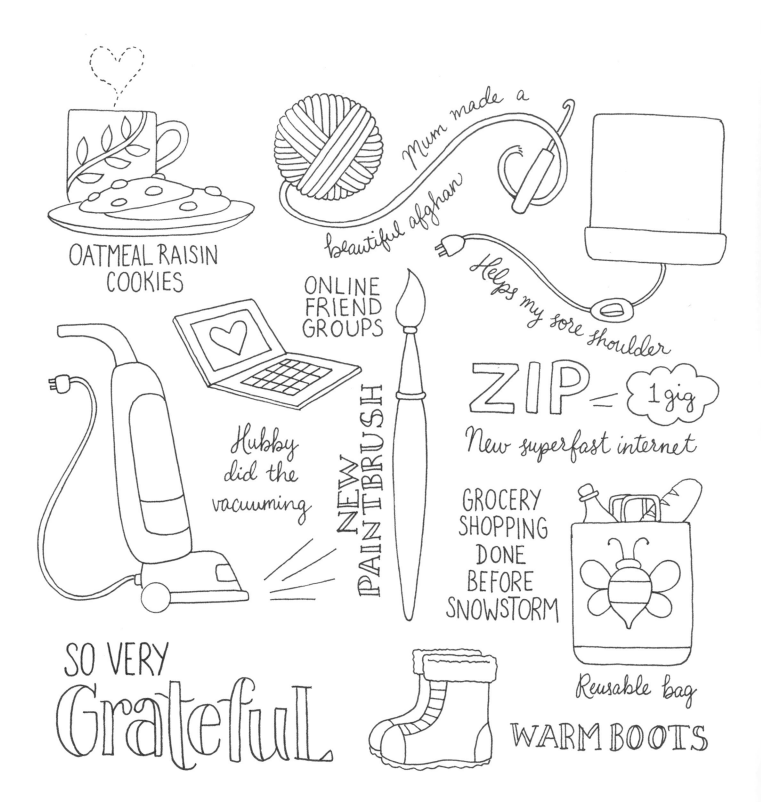

OATMEAL RAISIN COOKIES

Mum made a beautiful afghan

Helps my sore shoulder

ONLINE FRIEND GROUPS

ZIP = 1 gig

New superfast internet

Hubby did the vacuuming

NEW PAINTBRUSH

GROCERY SHOPPING DONE BEFORE SNOWSTORM

SO VERY Grateful

Reusable bag

WARM BOOTS

Step 2: Once you've worked out where you want everything to be in pencil, ink the lines with a waterproof fineliner pen.

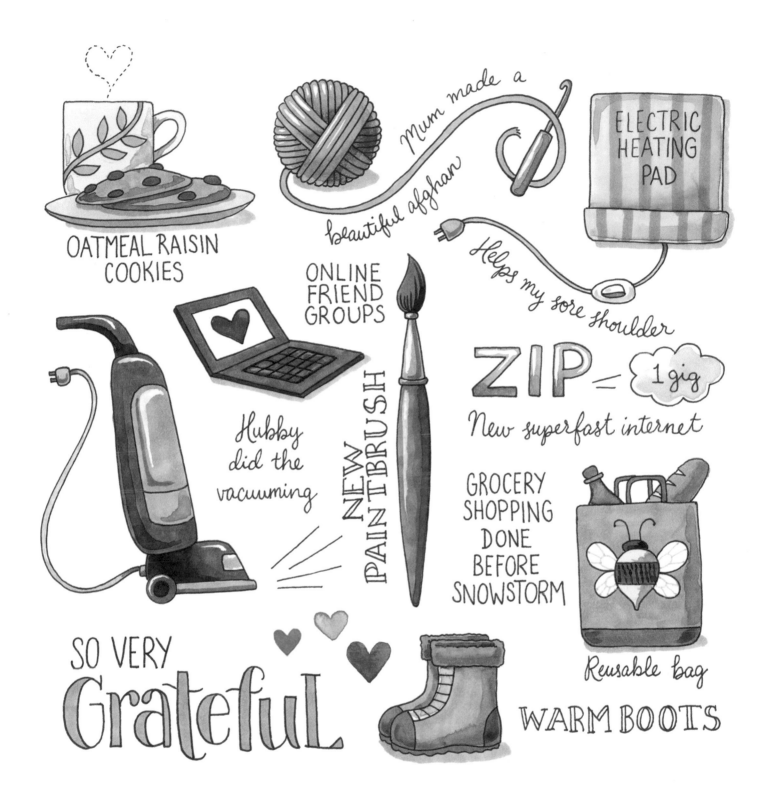

OATMEAL RAISIN COOKIES

Mum made a beautiful afghan

ELECTRIC HEATING PAD

Helps my sore shoulder

ONLINE FRIEND GROUPS

Hubby did the vacuuming

NEW PAINTBRUSH

ZIP — 1 gig

New superfast internet

GROCERY SHOPPING DONE BEFORE SNOWSTORM

Reusable bag

SO VERY Grateful

WARM BOOTS

Step 3: Color the page with watercolors. Sometimes I leave some of the page without ink outlines, such as the hearts on this page. I think a little variety adds freshness to the design.

COLLAGE CUTOUTS AND PRACTICE PAGES

The next several pages are blank on one side so you can cut out the images and paste them into your own journal. After that, you'll find blank pages where you can try out new ideas and practice things you've learned in this book. Happy journaling!

COFFEE

HOME SWEET HOME

GARDEN OF GRATITUDE

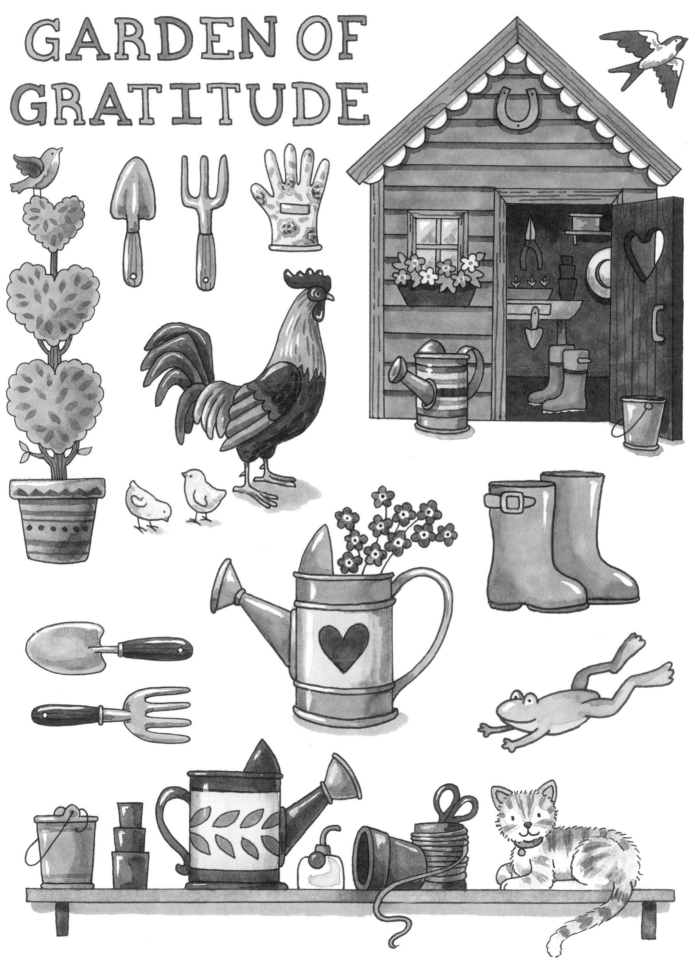

PLANT A GARDEN

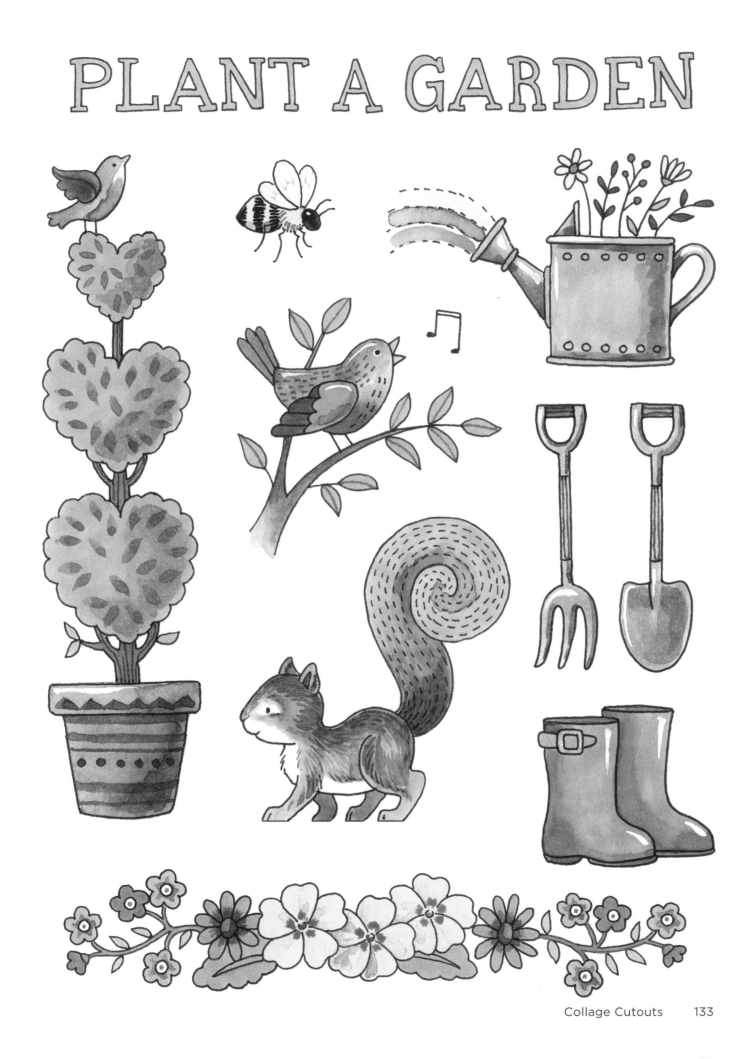

HOME COOKING

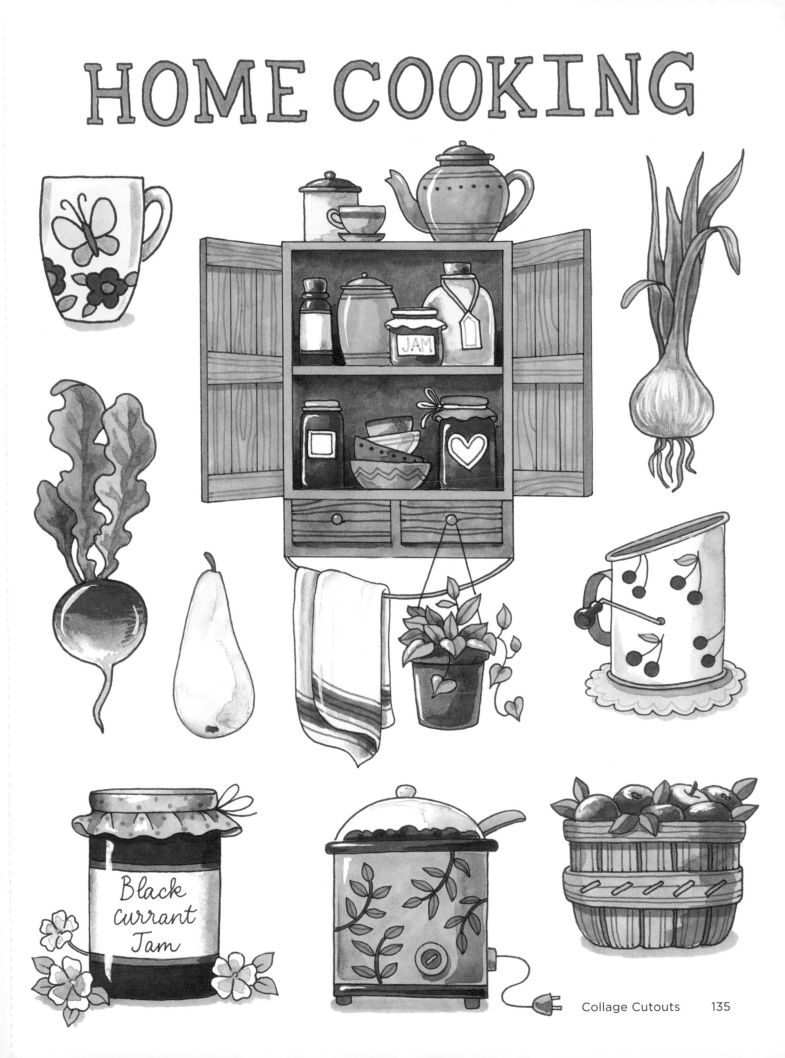

PRACTICE PAGES

ABOUT THE ARTIST

English Breakfast

IS POWERED BY LOTS OF TEA
(and sometimes dips her brush in the cup)

A LITTLE PAGE OF ME

my favorite GREEN BLUE RED

Art supply junkie

paints traditionally in

WATERCOLOR

LOVES HER SKETCH BOOK

Always does her best

PAINTS AND DRAWS all day

JANE MADAY

Has been a professional artist since she was fourteen.

Is also an author

is kind of shy

LIVES IN THE MOUNTAINS

Paints animals and birds

This book is dedicated to all my new friends in the creative world. It is so wonderful to be part of a community of kindred spirits. Many thanks to the crew at Soho and Get Creative 6, especially Pam, Lauren, and Michelle.